Michael Freeman's

101

Top Digital Photography Tips

Michael Freeman's

101

Top Digital Photography Tips

ILEX

Michael Freeman's 101 Top Digital Photography Tips

First published in the UK in 2008 by

I L E X

The Old Candlemakers

West Street

Lewes

East Sussex BN7 2NZ

www.ilex-press.com

Publisher: Alastair Campbell

Creative Director: Peter Bridgewater

Managing Editor: Chris Gatcum

Editor: Nick Jones

Art Director: Julie Weir

Designers: Jon Allen

Design Assistant: Emily Harbison

British Library Cataloguing-in-Publication Data
A catalogue record for this book is available from
the British Library.

ISBN 13: 978-1-905814-34-3

For more information on Michael Freeman's 101 Top Digital
Photography Tips, go to: www.web-linked.com/mfttuk

Printed and bound in China

101
Top Digital Photography Tips

Contents

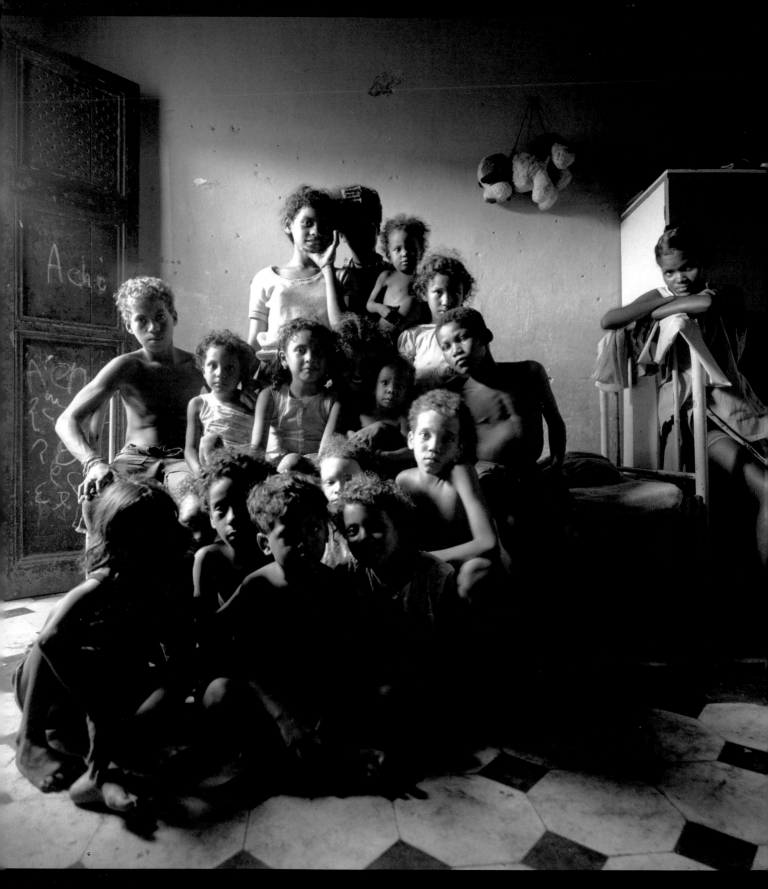

Introduction

With all the technical invention that goes into cameras, lenses, and the software needed to process images, you might be forgiven for thinking that photography is on a never-ending path to complexity. Digital capture seems to have unleashed quantities of information, techniques, controls, and features that we never knew we needed. And that's just it—the huge number of possibilities opened up by digital now threatens to swamp photographers in a morass of menu choices, buttons, mouse clicks, and, well, sheer exasperating detail.

I won't pretend that you can ignore all the technological advances and demands on your attention, but I can make a stab at cutting through the information overload. Here, in as simple and direct a manner as I can think of, are what I believe are the essentials for shooting.

At the end of the day, photography is about the act of taking pictures—you, the camera, and the subject you're facing. Just that.

Michael Freeman

Chapter_ 01

1 2 3 4 5

Basics

01

Just shoot

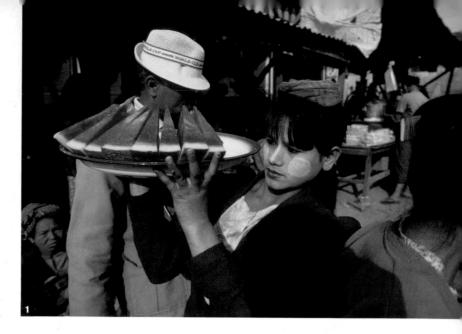

This is too simple a piece of advice, right? Not worth an entry in this book? I could almost agree, were it not for the fact that I've seen countless pictures lost or spoilt by general indecisiveness and dithering. And, sad to say, some of them were mine. The simplest scenario, and you can see it every day, has someone saying to friends "This looks good, let's take a picture." They all comply, get into position, smile, and… wait.

They wait while the photographer fiddles, or just for some reason can't quite get round to pressing the shutter release immediately. Yet under most circumstances that is all that is required.

And that was just a simple family-and-friends snap, which ought to be straightforward and undemanding. Out on the street, doing reportage photography, the timing and circumstances are less forgiving. Hesitate and you lose the shot. Of course, the arguments for delay sound cogent. All the technical aspects need to be right (exposure, focus, white balance, shutter speed) and more than that, the composition could be refined, the juxtapositions worked a little closer, the gesture or expression might improve in a few seconds… and so on. Nevertheless, delay can and does lose pictures, and for every reason to wait a second there is a solution. Need to check the exposure setting? Sorry to say this, but you should have checked it already, or at least chosen a workable default, such as Auto. And shooting Raw, which is another of my top tips, gives you latitude in several ways, from exposure

to white balance. The scene may improve in a few seconds? Right, but it may *dis*improve.

Being slightly more thoughtful, you could argue that you *save* time by spending a few seconds at the start checking the camera settings rather than shooting, then finding that some setting was wrong. But with any shooting situation that changes by the second or fraction thereof, there is never any going back. Henri Cartier-Bresson, the master of fast-reaction street photography, wrote "When it's too late, then you know with a terrible clarity exactly where you failed; and at this point you often recall the telltale feeling you had while you were actually making the pictures." And also, "We photographers deal in things that are continually vanishing, and when they have vanished, there is no contrivance on earth that can make them come back again."

Ultimately, you take a chance that you got it right. You can improve the chances by being prepared, and digital camera technology gives more opportunity for recovering mistakes than film ever did. But the most important ingredient in most photography is the moment itself.

So, press the shutter release, right away!

1 There used to be a piece of well-worn advice, maybe it's still around, about not photographing people with streetlamps sticking out of their heads. But I don't care—I liked this odd juxtaposition, especially the hat. There's never any time to think with a passing shot like this. You really do need to shoot instantly.

2 There was a little more time to think for this shot, but not much—just a few seconds—and catching the boy in the exact middle of the sun's reflection permitted no hesitation.

02

It happens only once

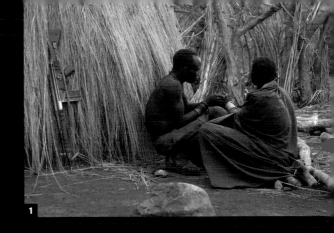

The subtitle for this should be "never rely on returning." This is one of those painfully obvious pieces of advice that call for one or two bad experiences to bring home the truth. Most photography is about the moment, and even though it may seem to matter less in some kinds (studio still life) than others (sports), it permeates just about everything. Even a landscape, which you might think is relatively static, has the dynamics of lighting and sky and possibly some other moving elements. The timescale is definitely not the same as in street photography, but even so, one moment for a landscape is not the same as the next.

If anything, the dangers of waiting might be greater for slow, fairly static subjects, simply because they don't seem urgent in any way. Planning a shot and thinking it through is a great idea, but every so often you'll be surprised, unpleasantly, that time was not standing still for you and the situation didn't get better. It's very easy to come across a scene, check it out, and predict that it should look great when the light changes just so, or the clouds move, or maybe tomorrow morning when the shadows will be falling the other way. Bit it's always "maybe."

Better insurance is to shoot the scene the way it caught your eye at the time. Apart from the time it takes to do this, there is no loss. You can still come back at sunrise or whenever, but if that doesn't work out you will at least have something already shot.

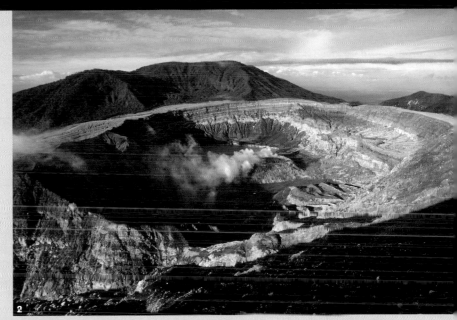

1 This was a Jie village in southeastern Sudan, and for one reason or another getting permission and access took a few days. Once acquired, I naturally thought about shooting at different times of day, but took the precaution of shooting like a maniac for the hour of daylight left on this day. And a good job too, because we had difficulty returning a second time.

2 Arriving late in the afternoon at the mountaintop overlooking this volcano in Costa Rica I saw that the clouds were beginning to close in, so rushed back to the rental car to get the cameras—and found that I'd locked the keys inside. By the time I found them (worse, they weren't in the car after all, but in my pocket), we were all shrouded in cloud. Sheer stubbornness kept me there for three days until it cleared, but it was not really worth the shot.

03

Shoot Raw

This is not simply a technical recommendation, but lies right at the heart of what digital shooting is all about. And that is, the special and unique relationship between capture and processing. The ideal in digital capture is to acquire as much visual information as possible from the real world, in particular color depth and a full range of tones. A high-quality digital SLR captures more of this kind of information than can actually be displayed, whether on a screen or in a print. This means there is potentially a choice in how the image is processed. If you start with more information than you will eventually need, it means you have the luxury of interpretation... provided that you don't throw it away at the start.

If you let the camera process the image for you on the spot, which is what happens if you shoot JPEGs or TIFFs, you are essentially going for one interpretation. For example, when you choose a particular white balance, there is no going back to any other later. This is not necessarily a problem, as any image-editing program such as Photoshop, Aperture, Lightroom, or LightZone offers ways of changing it, but there will be a very slight loss of quality if you do it this way.

More significantly, a good digital SLR captures a color depth of 12-bit or even 14-bit, which means more color information and potentially more dynamic range. Now, the color depth of all but the most sophisticated monitors is 8-bit, and that of a paper print even less, so you cannot actually view this

extra color depth, which might on the face of it seem a waste. But the crunch comes when you want to make any overall changes to the image in post-processing. If you shift colors or tones in an 8-bit image, there is a high risk of banding, or quantization effects. You can see this happen on the histogram, which after processing is quite likely to show a toothcomb appearance, with thin spikes. In a smoothly graded area of a picture, such as the sky, this will probably show up as bands.

The argument is to keep all the captured information intact until you are ready to process the image on a computer, and the way to do this is to save the image in the camera's own raw format, known appropriately enough as Raw. The general demand from photographers for shooting Raw has become so high that every serious camera model offers it as an option.

All this sounds so convincing, that why would you *not* shoot Raw? The simple answer is when you don't have the time. Raw images need to be worked on, while JPEGs come perfectly formed straight out of the can. Sports photographers working to a very tight deadline, as most do, are an example. And not everyone enjoys tinkering with images on a computer. If you get the settings right at capture, a high-quality JPEG is visually indistinguishable from a lovingly nurtured Raw file.

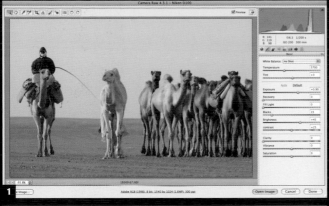

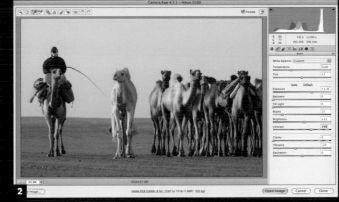

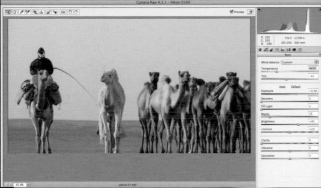

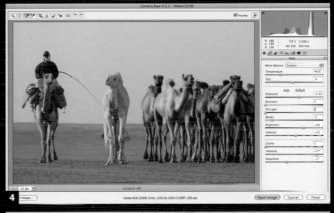

1-5 The white balance was set to daylight when I shot this camel caravan crossing the Nubian desert, but I still appreciated the luxury of being able to experiment with different lighting interpretations much later, at home. But perhaps the ability to process in a considered manner, without urgency, should really be a necessity, not a luxury.

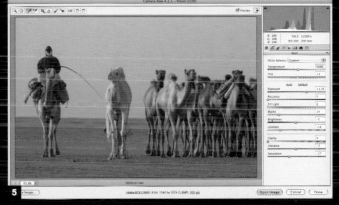

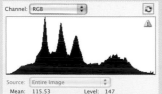

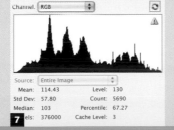

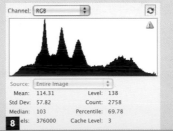

6-8 Histograms tell the story of an image given a contrast boost with an S-curve, and then the reverse curve applied to bring it back to its original appearance. **6** is as it started, **8** looks almost exactly the same when the adjustments were made in 16-bit, but **7** shows telltale spikes when the same operations were performed in 8-bit. Raw format allows 16-bit processing.

04

Shoot for the future

Otherwise known as the archival argument. The software for processing images continues to get better, and always will. That's one of the givens of software development, and whether your eyes glaze over or not at the thought of complex computing, the practical result is that you may be able to do more with your images in the future than you can now.

The one thing you can be certain of is that someone, somewhere, will think of a way of extracting more image quality from your digital photographs. What you judge to be a technical problem with one of your images may be solvable in a year or two. And a glance at what can already be done with a sequence of frames, in the Multi-shot chapter, is a taste of more to come.

Practically, shooting for the future means the following:

* **Be cautious of deleting for technical reasons (see Tip #6)**

* **Don't hesitate to bracket and shoot alternatives (see Tip #74)**

* **Shoot Raw whenever possible; the files contain more data (see Tip #3)**

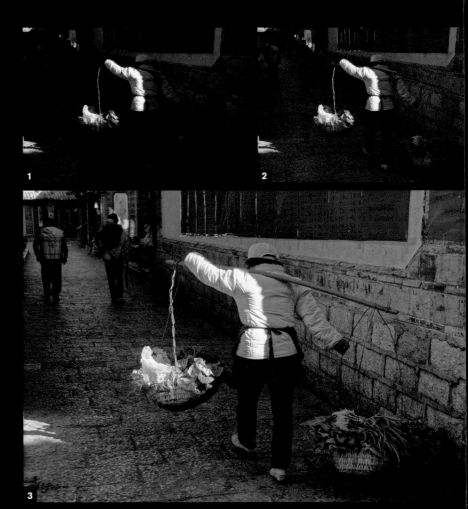

1 2

3

1-3 An interesting and telling example of what can be achieved with sophisticated processing. **1** is an original JPEG captured at the same time as the Raw file, holding the highlights on the woman's shoulders and her pannier, but losing huge amounts of shadow detail as a result. **2** is the result from processing the Raw file in Adobe Raw Converter, doing the best possible without significant clipping—still no better than you would expect. **3** takes a different approach. Here, two versions of the Raw file were processed using DxO Optics Pro, which applies tonemapping algorithms to accentuate mid-tone contrast, among other things. One version held the highlights, the second opened up the shadows. Both were then blended in Photomatix using the Intensive procedure. Finally, some adjustments were made using Curves in Photoshop. The result is visible detail everywhere, without significant noise, and a perfectly usable image. All this was done in several stages using three different programs, but could well be possible in the not-too-distant future in one operation during Raw conversion.

05

Prepare,
forget, shoot

If this sounds rather Zen-like, it is. No apologies for this, and there's no need to become mystical either. Zen happens to be a very practical interpretation of Buddhism, and among its more directly applicable tenets is the idea of endless practice and training leading to sudden insight. Henri Cartier-Bresson notably professed applying Zen training to photography. Fast-reaction photography demands an ability to respond and shoot faster than you can reasonably think, and the only way of having any effect on this is to train yourself.

There are several useful areas of training and preparation in this discipline, from the highly practical to the conceptual:

Camera handling
The operational side of shooting and dexterity with the camera controls. Basically, familiarity born of practice so that picking up and operating the camera becomes second nature. The camera, like any skilled craftsman's tool, becomes an extension of the hand.

Settings
The permutations of settings now available on advanced digital cameras are many. If you regularly find yourself in different kinds of shooting situations, there will probably be a few different combinations of setting that are useful for you. At the very least, check the settings as you approach any new

situation. So, for one example, if you anticipate that the main variable is likely to be speed of movement, you might want to select shutter-speed priority.

Observation
A huge and amorphous area of skill that goes well beyond photography, depending on alertness, interest, connectedness with what is going on, and speed of understanding. Something to practice at all times, even without a camera.

Anticipation
The logical extension of good observation—putting what you notice to practical use by predicting what may happen next. Extremely important in reportage, and absolutely essential in sports. Anticipating as a photographer, rather than just as an observer means being able to predict how an unfolding scene will work out graphically, not just the physical events.

Compositional strategies
If you can identify the kind of compositions that satisfy you, and what you need to achieve them (for instance, viewpoint, and focal length), and remember them, it helps enormously to maintain a kind of memory bank that you can draw on, as in "that kind of framing might work here."

1 Apart from timing and framing, a shot like this depends on exactly the right exposure. There is more than one way of setting the exposure to hold the tiny area of highlights, depending on the settings that your camera allows and whether you prefer to rely on auto-exposure or trust your experience. Preparation and confidence with settings are essential.

2 With sudden movement, only instant reaction can cope with the framing, especially with a wide-angle lens. Before this worshipper at a Coptic Christmas Mass reached out, I had the composition framed to the left. The camera followed the movement to the right, but also upwards slightly to use the diagonals and to reduce the area of her white-clad figure in shot.

06

Back up constantly

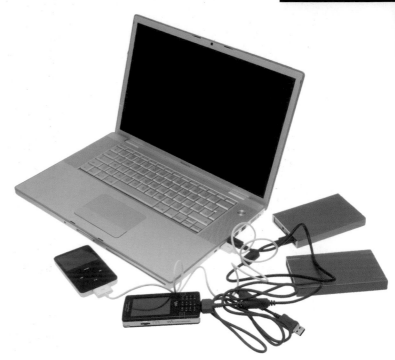

Backup onto anything and everything. Here, my standard backup devices are two small hard drives (right), but I also make use of my iPod (left), and even my cell phone.

I'll keep this short and to the point, because in truth there is not very much more to say than the title of this page. However, while backing up is not a subject that lends itself to elaboration, it is absolutely crucial to shooting. You ignore this at your peril.

The reason it does get ignored, despite all common sense, is that for most of the time everything in digital photography works seamlessly. The main brands of memory card have an exceptional record of reliability (fake cards offered at heavy discounts are a different matter) so equipment failure is rare. What you mainly need to protect against is human error, whether from forgetfulness, through fat-finger mistakes (hitting delete when you really meant something else), or general confusion. In the heat of shooting it is surprisingly easy to format (that is, erase) the wrong card, before its images have been transferred somewhere safe, such as a laptop or hard drive.

Everyone has his or her own way of doing these things, but if you haven't decided yet, consider the following procedure:

* Whenever you have a reasonable break from shooting, such as at the end of the day, download the images from the card(s) to another digital storage device (laptop, image bank, hard drive).
* If the software you use to download allows this, choose "incremental," meaning that each time you download from the same card, it adds only the images you shot since the last time. This

makes it easy to download frequently without having to bother with duplication.
* If you use a number of cards, follow a system that you are comfortable with to keep them in order. For example, I put a full card at one end of a container and take a new card from the other end. Or you could number them and tick them off in a notebook.
* As you download, number or name the image files according to your system, so there's no danger of overwriting files with the same name.
* Back up more than once. Keep copies in as many places as you can, even on an iPod.
* Keep backups physically separate, the more so the longer the shoot and the more images you accumulate. If you're flying, put one backup (such as a portable hard drive) in checked baggage or hand it to a friend.

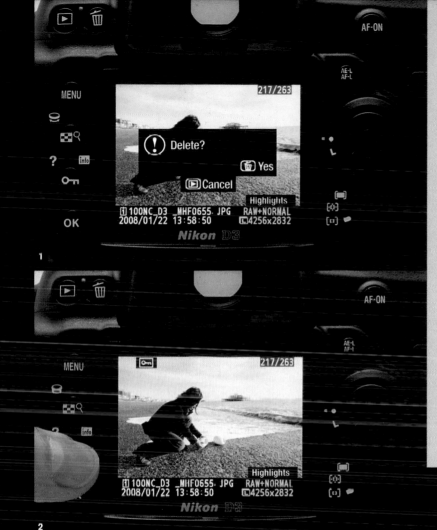

✳ Delete, caution

Some people hang on to everything they have ever shot like magpies, but usually, after the selection process, there are images that have no future use—rejects of one kind or another. The question is, when to delete? Only you can decide when you are absolutely sure that you have no further need for an image. Deleting in haste may satisfy a desire for tidiness, but you might be throwing away something useful. Here's one example. An overexposed frame that is almost (not even exactly) in register with another, better-exposed frame, can now be used for blending or HDR, and give better shadow detail with less noise. Content-alignment algorithms can now deal with many hand-held sequences. None of this was foreseeable a few years ago.

If the spring-cleaning urge is too strong for you to resist, and you feel you really must delete image files (because it's true that a few select pictures look better on the screen than a large number of also-rans), consider doing the following. Burn the soon-to-be-deleted image files onto a DVD or two, throw these in the back of the loft, and then delete them from your hard drive.

1 When and what you delete is a personal matter. Doing it in-camera is the most decisive and fully committed way, but if you have any doubts consider leaving it until the next stage—when the images are on the computer.

2 If you are in the habit of deleting as you continue shooting, it may be wise to protect key frames—many cameras offer this option. This protects against "fat-finger" errors.

07

Workflow questions you should ask

Workflow is a thoroughly digital concept, for the single reason that with digital photography, we're all responsible for our own images: shooting them, safeguarding them, processing them, and displaying them. The priority after any shoot, as we just saw, is to make backup copies, which cost nothing and are essential insurance. But more than this, you should spend time thinking about how you sequence your photography.

Workflow is about how images move through the different stages, beginning with the shooting. You fill up the memory card in the camera, and then what? What needs to happen before you post your selected images onto a website or print them? It depends on how much you shoot, what you shoot, whether you're traveling or at home, how much you like getting involved in the digital side of photography, and more. It's probably fair to say that every photographer's workflow is different. But what is important is actually to have a workflow planned out, rather than handle the images in a haphazard way, doing different things with them on different occasions.

If you have not already done this, questions to ask yourself at the start are:-

* How much do you shoot at any one time, and how frequently? You should know how many images you are likely to be dealing with each time you shoot, and also how many you think you may accumulate over a year.
This will affect editing times and procedures, and storage space.

* How severely do you edit? Do you keep everything, or only a small percentage? When do you like to make these editing choices? Right away, or do you prefer to come back to them with a cool eye after some time, maybe even several days?
This will affect the timing of different parts of the workflow.

* How much processing and post-production do you expect to have to do on your images? And are you shooting Raw, or JPEGs, or TIFFs?
This will affect how the images move through different software applications, and how many of these software applications you may need.

Once you've decided *how* you shoot, you can move on to the next step, which is to work out a personalized workflow.

08

Work out your own workflow

The usual workflow stages are as follows:
* Choose the file format to shoot
* Download images from memory cards
 as necessary
* Make backups and store elsewhere
* Edit the shoot to select the best images
* Process, with post-production as necessary
 (e.g. retouching)
* Caption
* Deliver selected images (e.g. to a client, or post
 to a website, or print)
* Copy images to normal permanent storage,
 with permanent backups

The following is my normal workflow, which I'm not
recommending, just showing it as one example:
* Shoot Raw plus normal JPEG
* Rotate memory cards as they fill up so that the
 oldest is always first for download
* At the end of each day, and sometimes during
 the day, download to the laptop using a browser
 program (Photo Mechanic), doing an
 "incremental ingest," meaning already
 downloaded images are ignored
* Once downloaded, images are renamed to fit
 my normal cataloging method
* If I'm away shooting for more than a day or
 two, I open a temporary database catalog (in
 Expression Media), and whenever I have a spare
 moment, start selecting images using colored
 labels, and enter place, subject, description, and
 keywords into the metadata. All of this later
 transfers easily to the main database catalog
 at home.
* At the end of each day, back up the images
 twice, to two portable hard drives. These drives
 are kept physically separate.
* If I have time or an urgent need, I process the
 selected images on the laptop, using DxO Optics
 Pro. On a long trip, I try to keep pace with the
 shooting, so that all the selected shots are fully
 processed by the time I return home.
* Whenever I find a good connection, I make
 high-quality JPEGs of the processed images
 and upload them via FTP to my website.
* On return, I copy all the images to the RAID
 (Redundant Arrays of Inexpensive Disks) that
 acts as my image bank, and update the
 database catalog. Make backups onto two large-
 capacity hard drives. Delete the images from the
 laptop, and from the portable hard drives when
 they fill up.

How the image moves through the hardware

camera

memory card

card reader

computer

How the image moves through the software

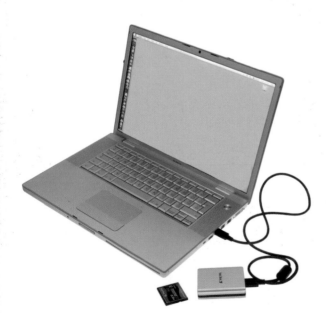

Transferring images from the memory card is the first, and in many ways most critical step in the digital workflow. Here, a Firewire reader is used to transfer to a laptop, but there are other methods and other devices that can be used. The software used is Photo Mechanic, a browser.

It's important to have a consistent process for downloading your images in order to avoid mixing up memory cards (if you use several). Formatting before transferring the images is the most likely disaster. My simple method involves moving cards from bottom to top in a cardholder—but I rarely use more than two cards in a shooting session.

hard drive for permanent backup

portable hard drive for temporary backup

RAID or hard drive for permanent storage

DVD or tape backup

desktop printer (for contact sheet & proof)

modem (for delivery on-line)

image-editing software, including Raw connverter

image database

onboard processor in camera

browser

third party filter plug-ins, e.g. noise reduction, effects

e-mail or FTP

archiving or backup software

09

Situational awareness

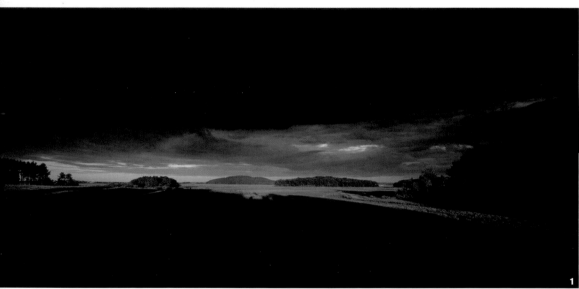

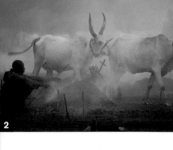

1 There was more time to think here than with the other image, as a storm crossed the Massachusetts coastline. For an hour before this moment, the clouds were unremitting, but some knowledge of the weather conditions and the speed of the wind suggested the possibility of a break. It came, briefly.

2 The small cross in the center, the purpose of which to this day I don't know, is an important part of the image. I positioned myself to catch the moment when it would be visible in a gap between the two cattle as they crossed my field of view in a Dinka camp in Sudan.

It might seem that I'm over-emphasizing street photography and reportage, which I suppose is true, but this is one of the most demanding areas in photography when it comes to dealing with the unexpected. Probably all the lessons learnt here are applicable in other fields, usually with more time and certainty. Situational awareness is the condition of knowing where you are, what's happening around you, and how the different elements, people, and events are interconnected. Not often touted as a photographic skill, it is, I would argue, the *most* important for any situation that is not under your complete control—and that means just about everything outside a studio. You could also call it "connectedness," the quality of being properly embedded in the situation you are shooting. If it's a specialized field, like wildlife, and that's also your chosen field, you certainly understand this already,

and the need to know as much as possible about your subjects. To continue a little further, with wildlife as an example, knowing a particular animal's behavior is key. In the location, ready to shoot, you would apply the experience and knowledge to the local surroundings.

In a more general field of photography, like reportage or landscape, this knowledge base may not be so obviously specific, but it exists nevertheless, and checking out the dynamics of the scene is always worth concentration, until it becomes second nature. Unless you do this already, consider making a special effort in a situation to analyze what is going on and why. For people, try it in an airport, in a street market, in a restaurant, anywhere. For landscape, look at the weather, the light, the layout of different elements, and the different scales from large to macro.

10

Stay with the situation

This applies to certain kinds of shooting, notably reportage. What counts as a situation? Well, it could be a large event in which there is space and time for you to move around and find many different kinds of image, or it could be a specifically framed shot in which the elements may, or may not, change. It's the latter that I'm particularly thinking about here, because it involves decisions that can improve a single, already conceived shot. The assumption is that something about the situation has already caught your eye. It could be content, as in the picture here of people passing in front of a billboard, or it could be lighting, or some other pictorial quality. Occasionally, it all comes together in a single moment that you know in your guts is right, and that's it. More often, if you think it through, it's a good image, but could be even better if only this or that happened. I'm illustrating this here with a quite standard class of image, of people passing in front of a striking backdrop. The graphic possibilities are obvious, but there is also room for an added level of contrast or coincidence. A situation like this, if you have no pressing need to move on, may be worth several minutes or more.

Staying with this general theme of people against graphics, look at the second image, also shot in Shanghai, of a visitor to an art museum. She is having a friend photograph her, which would not ordinarily make a very interesting subject—too planned and self-conscious—but does she know that her hair matches the panda's ears? Of course not, and neither did I until a friend pointed it out. This, of course, is not a preconceived shot, but it became available by hanging around.

Having waited, you then face the decision of when to quit. Often, a situation with changing elements is subject to the law of diminishing returns, meaning that after a while you have seen most of what is likely to happen, and it is unlikely that there will be any great surprises. But "unlikely," of course, is the prize in many situations, and you never know what might happen. At this point, you need to weigh the value of staying on in the hope of an improvement against moving on to something else.

1-7 As described in the text, this kind of scene, where you have one element and are waiting for the best possible second element (people), demands some patience and waiting time. The best shot is not necessarily the last, of course.

8 After you have shot what you can think of (here a modern art gallery in Shanghai), hanging around may reveal the occasional unexpected bonus.

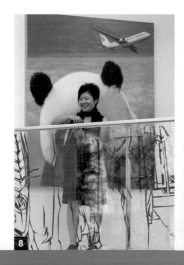

.1

Explore
the subject

There may be more to a scene than the first thing you see. This applies as much to different views of a building or landscape as it does to an event involving people engaged in some activity. Human nature being what it is, however, once we think we've caught the essence of the subject and have a few good shots in the can, it is very tempting to call it a day and move on. This isn't necessarily laziness, more like complacency. Paradoxically, the better the shot you feel you've just taken, the less it's likely that you'll want to hang around. But you may be missing out.

There are two ways of exploring further. One is to examine the situation, looking for other things going on or different viewpoints. The other is to explore with your camera techniques, seeing how the same thing looks with a different treatment, such as a change of focal length or a variation in lighting. The underlying principle is that there is almost always something new to discover. You may have a good reason for moving on—there might be an obviously good photograph waiting to be taken a short distance away—but if not, try and exhaust the possibilities of the subject that you started with.

Of course, at some point you do have to stop. Ansel Adams wrote, "… I have always been mindful of Edward Weston's remark, 'If I wait for something here I may lose something better over there.'" Well, that's the photographer's dilemma.

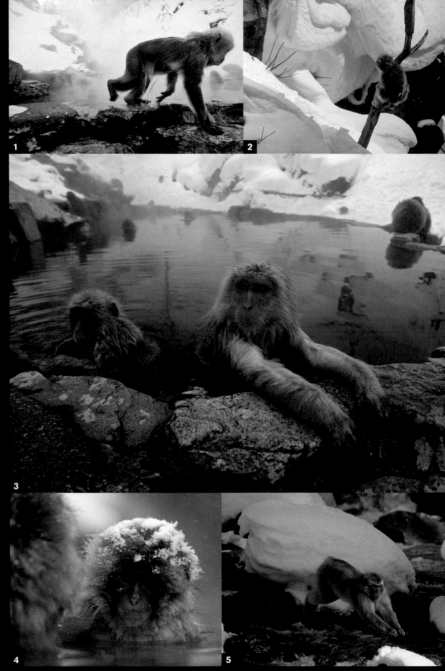

1-6 Snow monkey series
Every scene and every situation has different aspects, and one of the basic skills for any kind of reportage photography is to cover the subject as thoroughly as possible. In the case of these snow monkeys in winter, in the Japanese mountains of Nagano, it meant emphasizing behavior and varying the scale from close-up portraits to action within a setting. And, what is not usually recorded in photo-stories of these well-known simians is that on weekends there are often more photographers than subjects!

12

For candid, shoot blind

If you want to shoot candidly in a close or crowded situation, where being seen to be taking photographs might be embarrassing or intrusive, and especially if you want to *continue* shooting rather than simply grab one shot, this strategy may help. Instead of raising the camera to your eyes, which is a complete giveaway, hold the camera lower, such as at waist level, or in your lap, or place it on a table, then squeeze the shutter release without looking at the camera. Shooting blind was very hit or miss in the days of film, although one possible technique was to remove the pentaprism (some cameras allowed this) and look down onto the ground-glass screen, perhaps even pretending to clean the camera in the process.

Digital cameras, however, make shooting blind a worthwhile possibility, as you can immediately check the framing and composition by turning up the back of the camera to look at the screen after the shot. This is a situation where it helps to have everything on automatic, from focus to exposure. Aim and frame as well as you can, check the result, then adjust focal length and position until you get it right. It may help to look at other things as you shoot, so as to be even less obvious. You can learn to predict the framing quite well if you keep the camera on a strap on your chest, where it should hang fairly straight. Practice with a particular lens or a particular focal length on a zoom, so that you know more or less what the result will be.

If the camera has a live preview (also known as live view), you may be able to hold it in such a way as to have an angled view of the screen, which makes framing much more accurate. But the time and attention you spend looking at the screen may negate any efforts to be surreptitious.

1 A Burmese man sitting in a cafe in Rangoon. I liked the lighting, but was too close to raise the camera and expect to shoot unnoticed. The shot was taken with the camera propped on my table, next to a teacup.

2 Sitting opposite a family waiting in a crowded bus station, I had plenty of time to guess and try the framing and zoom for this waist-level shot, the camera held on my lap. I tipped it forward between shots to check the view in the screen, and adjust accordingly.

3 Many SLRs now incorporate a live preview option, and even at an extreme angle, as when holding the camera at waist-level, this is a perfect guide for composition.

13

Give chance
a chance

2-5 Even with the mobility of a helicopter, making a low pass in a circle often gives no second chance. The view sweeping past the open window is unpredictable at this altitude, and while the subject I was aiming for was the group of cone-shaped mausoleums, I suddenly caught a glimpse of the passing figure. This was a prime, non-zoom lens, so reframing was the only choice. Even though the top of one building is just clipped, the framing on the first shot was good and effective. I then immediately reframed for a vertical in the hope of including the figure and all of the buildings, but this worked less well. The helicopter continued its counterclockwise pass, taking it closer, so there were no more similar opportunities, just close-ups of the buildings.

Photography is a medium in which images are regularly created in a fraction of a second; accident can play an important part. If, that is, you allow it. This happens most in street photography, and while many chance happenings are unwanted or just not interesting, as when someone walks across your field of view and obscures what you are shooting, sometimes they give you an image that you could not possibly have planned. But chance in

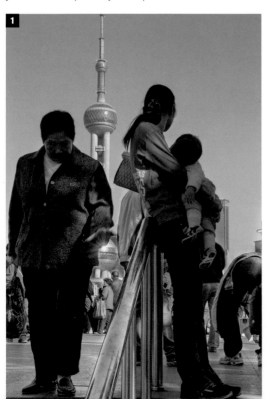

photography does depend on your willingness to let it happen—to keep on shooting when things don't turn out quite as you expected. Digital shooting removes the one serious reason against this—that of wasting film. You can always delete later, though see Tip #6 for the dangers of doing this hastily.

Chance can take over from artistic intervention in any number of ways, but there are two useful distinctions: when you can see it happening as you shoot, and when you discover it later. The latter is what happened here, in a shot taken looking up a flight of steps on Shanghai's Bund—the riverfront. I was looking for juxtapositions of people coming and going, but also wanted to catch the brightly colored reflection of the sun that was briefly captured in the globe of the Oriental Pearl Tower on the opposite side of the river. There was a lot of movement across the frame, and I was shooting whenever there was a gap. Among the shots I looked at later was this one. The movement of the woman's hand as she lowers it to steady herself on the handrail was too quick to pay much attention to as I shot, but it has a strange impression of the hand being held over the light.

1 As described in the text, I was trying to catch the colorful reflection from the distant tower between the constant to-and-fro of people. Even so, I didn't realize that this exact moment would give a strange impression of the woman holding her hand over the light.

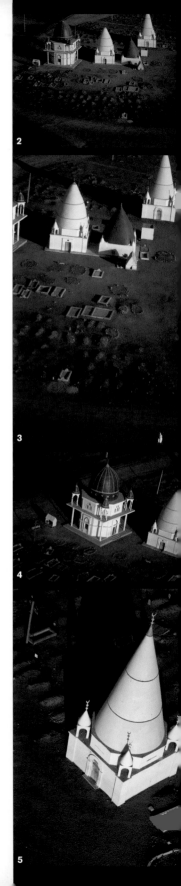

14

If you're uncertain about permission

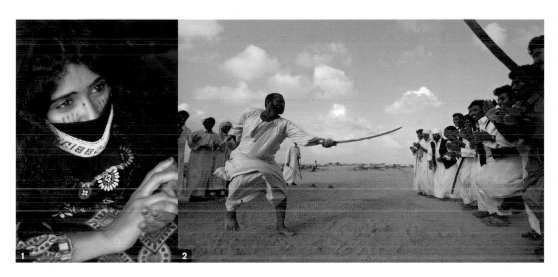

1-2 In many Islamic societies, women are not only veiled, but are off-limits to male photographers. Taking pictures this close absolutely requires prior consent, as was sought for this young Rashaida woman in eastern Sudan. And you can see that Rashaida men are not to be trifled with.

3 One of the peculiarities of India is that among the list of forbidden subjects for national security reasons are bridges. All bridges, even fine old ones like the Howrah Bridge over the Ganges In Calcutta are off limits, so shoot quickly and out of sight of the police.

I'm not talking here about the formal rules issued by museums, archeological sites, and the like, but about what is acceptable and unacceptable in different societies and cultures. We all know our own, but traveling can put you in situations that are unfamiliar. Religion may come into it, and cultural values may not be what you are used to. The fundamental conflict, to which most photography is prone, is between polite behavior and getting the shot. By the nature of what we do, photographers tend to be intrusive, often pushing the limits of what is allowed in order to capture a more striking image.

The more uncertain you are about what you can and cannot do in a different society, the more important it is to do some basic preparation, such as reading up on the place and the society. Where religion is culturally important, as in many Muslim, Hindu and Buddhist societies, you should find out the basics before you arrive. In general, however, the following tips work in most places and circumstances—they are, after all, common sense:

* If in doubt, watch what other people do first
* Be polite
* Smile a lot
* Don't draw unnecessary attention to yourself
* If you think you've really put your foot in it, move away
* Never display anger
* Ask permission only if you think you'll get yes for an answer, as once denied you've had it. It might be better to shoot first, then apologize with a smile
* Show people the playback view, but ONLY of smiling portraits
* Learn at least a little of the language. It shows you're interested

3

Chapter_

02

15 16 17 18 19

Exposure

15

Know your dynamic range

Dynamic range is critical in digital photography, more so than with film. First, film is more forgiving because its response to light tails off gently at either end of the scale, while a digital sensor has a more abrupt limit. So, if you over-expose, don't expect to be able to recover much information from the blown highlights, and much the same applies to under-exposure. The second reason for its importance is that dynamic range varies between brands and models of camera. With film it hardly mattered which camera you used, but with digital, the dynamic range depends on several factors, and manufacturers often withhold full information to keep a competitive advantage. A great deal of research goes into this area, with constant development, and considerable secrecy.

If you have a high-end digital SLR, you can reasonably expect the dynamic range to be better than a cheaper model, but another factor is how new the model is. Often, a newer second-tier camera will perform better than an older top-of-the-line model. It makes sense to know your camera's abilities. Once you do, you can put this information to practical use by having a pretty good idea about what kinds of scene your camera can handle successfully without losing image detail and without calling on help from extra lighting or reflectors.

The main factors that control the dynamic range of the sensor are the bit-depth, the size of the individual photosites, and the noise characteristics. First, bit-depth. Greater bit-depth means that the

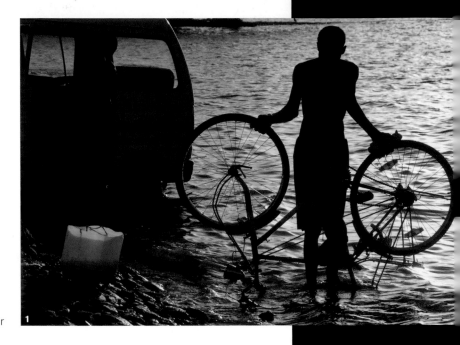

sensor has the capacity to record a wider range of brightness, so a 14-bit sensor potentially records more than a 12-bit sensor. To take advantage of this, however, the sensor needs other qualities. One of these is the size of the photosites. The larger they are, the better, and the less prone they are to noise at low levels. Some sensors have extra technologies to improve the range, such as Fujifilm's Super CCD SR II, which has two photo-diodes in each photosite—a larger one for general use, and a smaller one that reacts to high brightness levels.

Finally, the noise characteristics. Noise, as we'll see in more detail in the Low-light section, has its biggest effect when there is least light, as in shadows and low lighting. More than bit depth, it limits the dynamic range of a sensor at the lower end. This is know as the noise floor, and you can see its effect by trying to open up shadows in any image beyond a modest amount. If you do this in a Raw converter, when you increase the exposure or brightness control beyond a certain point, you will simply be revealing more noise than real detail.

Treat manufacturers' claims with caution, as it's easy to make the performance sound better than it really is (being optimistic about the noise floor, for instance). Check your camera's dynamic range as described on the opposite page.

Gray card

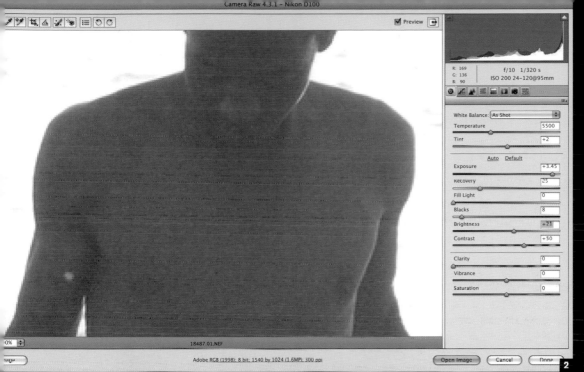

1-2 Currently the biggest limitation to the dynamic range of camera sensors is the noise floor—the darkest part at which real content detail can be distinguished from noise. In this silhouette shot, opening up the deepest shadows—by almost 4 stops—shows that noise swamps many details of the man's face and torso. This is the noise floor. If the sensor's performance were better in this respect (this was a Nikon D100), its dynamic range would be greater.

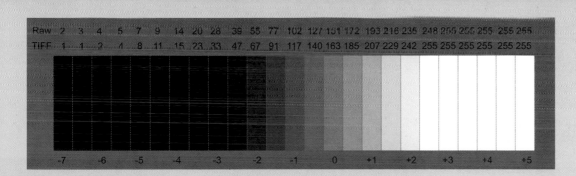

✳ Check the dynamic range

Photograph a gray card (see Tip #27) under even lighting that doesn't change, and defocus the lens strongly for an even tone. First, shoot at an average exposure setting, then take a series of frames at one-half or one-third *f*-stop intervals, both darker and lighter, at least 6 *f*-stops darker and at least 4 *f*-stops lighter, so that you have a range from completely under-exposed to completely over-exposed. In a browser, database, or image-editing program that allows you to measure the brightness, assemble the images in order, and label each with their exposure.

Measure the values on the usual 8-bit scale from 0 to 255. Find and mark the step on the left-hand side that measures 5 (anything less is effectively black). Find and mark the step on the right-hand side that measures 250 (anything higher is effectively white). These two extremes set the dynamic range. If your camera shoots Raw, measure the values as you open each image in a Raw converter. In this example, the Nikon D3 captured a range of almost 9 stops. Note that the increases in exposure reach pure-white saturation (255) more quickly than the decreases reach pure black.

16

Know the scene dynamic range

These five examples are self-explanatory. The variable is what you as the photographer considers to be important, and this becomes an issue with two of the images here—the beach shot of three round art objects, and the evening street scene. If it were important to hold all the detail in the sun's reflection or all the detail in the street lamp, then no camera sensor will be able to do this in one exposure (two or more exposures combined is possible, see Tip #76). If you let these go, then there's no difficulty.

The dynamic range of a scene is a measure of its contrast—absolutely key in digital photography where sensors are unforgiving of over- and under-exposure. If you make yourself familiar with the dynamic range of typical situations, life will be a lot easier. Recognizing at a glance a dynamic range that is beyond the camera's ability to capture gives you the chance to take appropriate actions, which can vary from changing viewpoint and composition to take in a smaller range, deciding which brightness zones you are prepared to sacrifice, making a mental note to use special recovery techniques in the processing, or shooting extra frames with a view to later blending them or making an HDR image.

One important qualification is that the practical dynamic range depends on what losses you are prepared to accept. Most photographers would let specular highlights blow out, and many would be happy to have the deepest shadows go to full black. Indeed, most of us are conditioned to feeling that photographs have a certain look that does *not* present highlights and shadows containing much detail. This is, after all, photography we're dealing with, and not the scientific rendering of every scrap of detail. Photography, many would argue, including me, looks realistic and believable only when it covers a dynamic range that we're familiar with.

So, when you look at a scene, even before raising the camera, it's a good idea to decide what is important and what is not. You can probably discount some of the small and brightest highlights, as you

can small, deep shadows. There's no formula for this. Every scene is different, and your judgment will differ from mine. But the effective dynamic range covers just the parts of the scene that matter, and no more.

The examples here cover a fair range of situations, and tell the story more eloquently than any further description.

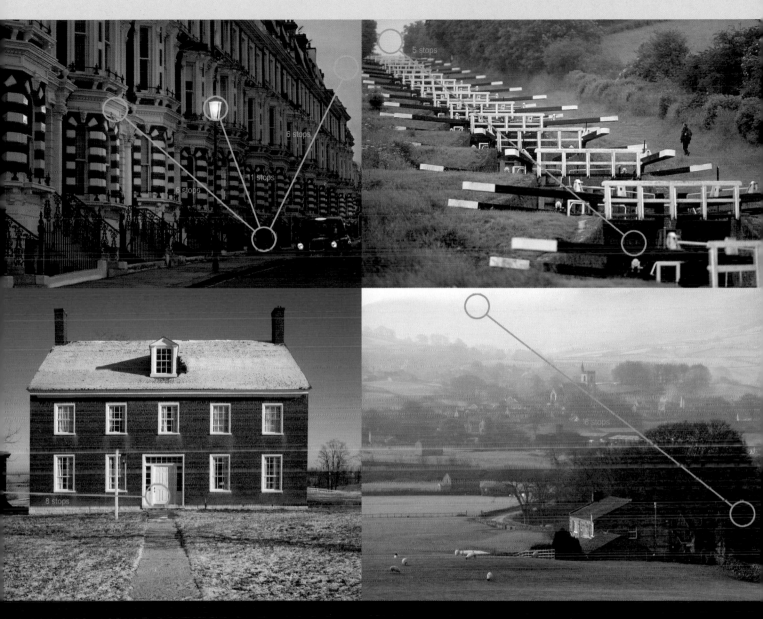

Scene *f*-stop range equivalent	Scene	*f*-stop range equivalent
	Deep shadow under rock to the sun's disc	more than 30 stops
	Dim interior with view through window to bright sunlight	12-14 stops
	Moderately open shadow to the sun's reflection in water	10-12 stops
	Dark surface in open shadow to white surface in sunlight, mid-morning or mid-afternoon	8 stops
	Overcast day, under-tree shadow to the sky	5 stops

17

When good histograms go bad

Histograms may not at first look like a sympathetic way of judging images, but with experience they can become a fast-track assessment of exposure, brightness, and contrast. Faster even than looking at the image itself on the camera's LCD screen. If the highlight clipping display is the most critical (in my opinion, anyway), the histogram runs a close second. Learn to recognize the telltale signs of a problem histogram—one that shows that the image is either not well exposed or is going to cause difficulties in post-processing.

The histogram is a kind of map of the tones in an image (and of the colors if your camera displays the red, green, and blue histograms also). On the left is black, on the right white, and the shape of the histogram shows you how the tones are distributed.

Look first at the left and right edges. If the histogram is crushed against either end, you have an exposure problem. Crushed against the left means underexposed shadows—too much of the image lost to black. Crushed against the right means blown-out highlights. When this happens at both edges at the same time, you have a very contrasty scene and have both shadows and highlights clipped. If, on the other hand, all the tones sit well inside the scale, not reaching either left or right, the image is low in contrast. No technical problem there, unless you later decide to expand it to a full range of contrast, in which case you will need a 16-bit image to avoid any banding.

Underexposed

danger point = the left edge; too many tones crammed up against it, with almost certainly some lost to pure black

solution = plenty of room at the right, meaning it can take more exposure without clipping highlights—at a rough guess, about 1 1/2 stops

Overexposed

danger point = the right edge; too many tones crammed up against it, with almost certainly some lost to pure, featureless white

solution = lots of space at the left to reduce the exposure without clipping any shadows

High contrast

danger points = both left and right, losses in shadows and highlights

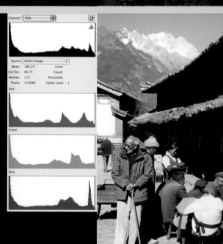

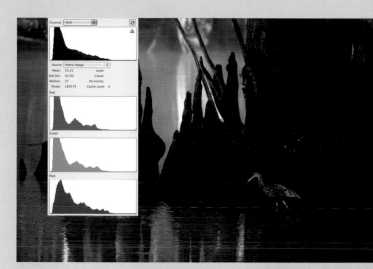

Dark

danger point = most of the tones clumped at the left end. If you want the image dark, fine, but opening up the shadows means either increasing the exposure (and so clipping highlights), or special post-processing, which calls for a 16-bit image

solution = no leeway on the right to increase exposure without clipping

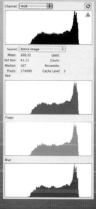

Low contrast (left)

danger point = none immediately, but as all the tones are squashed into a small part of the scale, processing this image so that it has a full scale from black to white will mean "stretching" it, which is likely to create banding "steps"

Bright (right)

danger point = most of the tones concentrated on the right. Depends entirely what you want from the image, but it may need to be darker, through exposure or post-processing

solution = no room on the left to reduce exposure without clipping

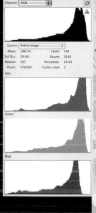

Small, intense highlights

danger point = occupies a tiny spike, but is it important? If so, it needs to be clear of the right edge in order to keep the delicate tones

18

Be histogram-literate

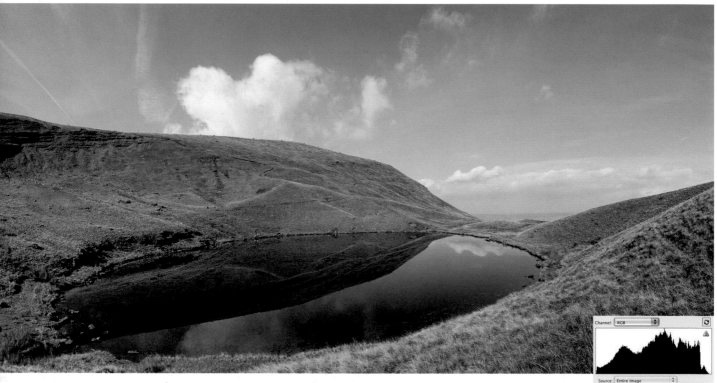

Histograms are not only good for trouble-shooting, but also for understanding the finer points of exposure and contrast, and the more you understand, the better you can fine-tune your results. The idea is to learn how to read a histogram, and the best way to do this is to look at photographs and their histograms together, to identify which parts of the image relate to which peaks and troughs in the histogram. It's designed for at-a-glance visual communication, and wordy descriptions are much less useful. That's why I'll devote most of these two pages to pictures, not words.

Diagnosis: a good range of tones, from bright to dark, occupying the full range and without clipping. The color channels show a difference, as you might expect, with blue strong on sky and its darker reflection in the small lake (hence two separated peaks). Add all together in an RGB histogram and you can see, from left (dark) to right (light), the shadow parts of the lake, a central peak of most of the grass (merging with a right-hand peak of the blue sky), and finally, a tiny small peak representing the white cloud.

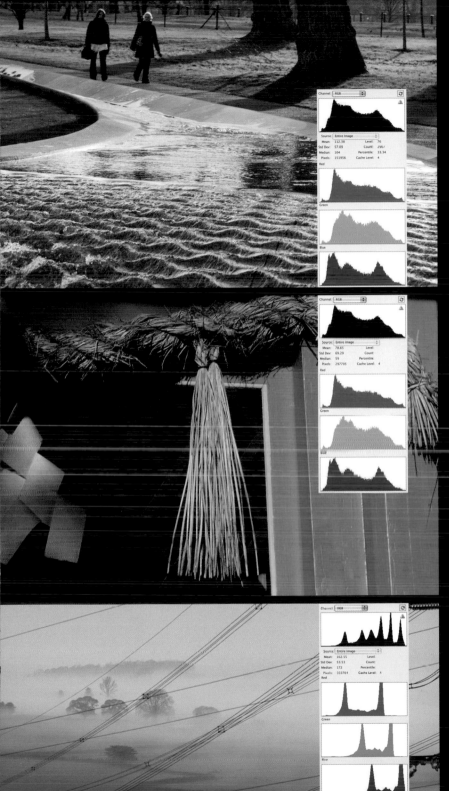

Diagnosis: the grass in this backlit shot may look pure at first glance, but like most vegetation it has more red in it than you might expect—it occupies the right-hand peak in the green channel but also the right-hand part of the red. The left-hand peak in all channels represents the silhouetted trees and people. In the blue channel, the second peak in from the left is the scalloped blue foreground water, while the bright water occupies the right-hand slope in all channels, with a peak in the blue.

Diagnosis: this detail of a Shinto shrine is segmented, as it appears to the eye, with a clear zone of dark shadows and another distinct area of light tones (the orange wood and the hanging straw). As they march rightward from blue to red, the color channels also show that the shadows are cool and the bright areas are warm.

Diagnosis: although many people would at first say this is a soft, low-contrast scene, it has been processed to cover the range from black to white. Perhaps surprisingly, the dark parts of the power lines and pylons are hardly visible; they are very low, but reach the left edge. The regular succession of peaks show what the eye tends to skip over—that far from being a smooth transition of tones, the misty landscape is actually zoned. The color channels show that blue dominates in the highlights, and green in the mid-tones, and that yes, there is indeed red present.

19

Shoot for the highlights

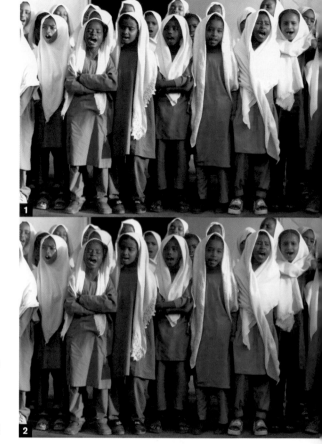

All exposure issues revolve around one condition—high contrast, *aka* a scene with high dynamic range. This is nothing new; photographers have been dealing with it forever. The most basic strategy is also not new—exposing to hold the highlights. This held true for color transparency film in particular, and especially so for Kodachrome, which was the professional choice for many, but behaved very badly when overexposed, giving unpleasant, washed out highlights. In high-contrast situations where there are few choices to balance the lighting and no opportunity to take multiple exposures, which is to say most location situations, the choice is whether to lose the shadows or the highlights. In almost every case the best strategy is to lose the shadows.

As it happens, there are more techniques for recovering shadow detail digitally in post-processing than there are for recovering highlights. As we saw, the real practical limit to the sensor's dynamic range at the low end is the noise floor. So few photons are striking the photosites that real recorded detail becomes indistinguishable from noise. Nevertheless, there are different solutions within the camera's processing and in software afterwards for smoothing out this noise. Even if the results may sometimes be artificially smooth, they can often be made visually acceptable. Unfortunately, no algorithm can deal with the total loss of visual information in an overexposed highlight. If all three channels are blown, meaning that the photosites are 100% full,

the resulting pixels are simply empty. There is a partial solution when some data survives in one or two of the three channels, as happens with, for example, ACR's Recovery, but it does not go very far.

That's the technical argument for preserving the highlights when shooting, but probably more important is the perceptual one. The eye pays more attention to bright areas in a scene than to shadows, and while a high-contrast view in which the highlights have detail but shadows are deep is acceptable (even though recognized as too dark), the converse is not. Fully opened up shadow areas with washed-out bright areas just look wrong to most people. That isn't to say that you can't make a good photograph like this—this is what high-key photography is about—but it doesn't fit with what we perceive as a reasonable record of a scene.

Having said this, you need to define what the highlights actually are in a scene, which is to say, do they matter? Few people would feel the need to capture detail in a specular highlight, such as a reflection of the sun in a car windscreen, or detail in a visible ceiling lamp. These are actually possible to preserve by employing HDR techniques, but are

1-4 Shots 1 and 2 of these Sudanese schoolchildren, were closely spaced but at different exposures—the lighter one overexposed by one *f*-stop—and it shows in the white headscarves. In **3** there is no clipping as the exposure is deliberately for the highlights, and clicking Auto in Adobe Camera Raw shows that there is even a little room for *increasing* the brightness. The over-exposed shot has been processed using maximum Recovery in ACR, which attempts to claw back highlight detail. Even so, the two brightest headscarves, right and far left, are a lost cause as there is no detail to recover.

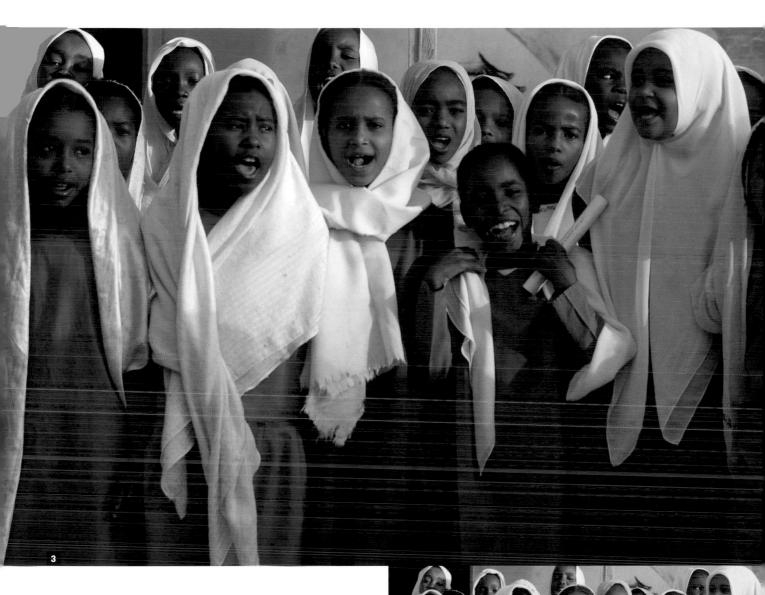

3

normally not expected to be. You can go further with this by accepting flaring sunlight flooding through a door or window in an interior photograph, or by deliberately choosing a high key treatment.

The most useful of all the camera's playback settings is the highlight warning, which takes the standard form of flashing black and white. Admittedly (and intentionally) distracting, it shows which areas are blown and unrecoverable, though usually with a margin if you use techniques such as ACR's Recovery.

4

20

Choose the key

1

The "key" in imagery is as it is in music—the scale of tones for any one image. High-key means generally bright, low-key generally dark, though there are many variations within these. While there is often no choice for the photographer, and you simply have the tonal range that confronts you, there are situations when you can decide. On location this may mean redefining the subject and reframing, but in a controlled environment like a studio, or in close-up, there is every opportunity. If you have control over the lighting, then by musical analogy you are the composer, and choosing the key of your composition is clearly of some importance.

For some reason, key receives less mention now than it used to, which was never very much, but it adds another layer of creative decision, which is always useful. In film photography, the extremes of high-key and low-key tended to be the province of prints from negatives, where tones were easiest to manipulate. Digital processing, of course, gives more opportunity.

There are two steps in choosing and working n a particular key—shooting and processing. In shooting it means finding a subject and composition that lends itself to a particular treatment, and then exposing accordingly. Scenes that have the potential to work well in an extreme key are those where almost all the tones are in a similar register, so generally low in contrast. Some landscapes work well, as do brightly lit portraits of Caucasian skin for high-key, and less bright portraits of dark skin (with tonally matching backgrounds).

When exposing for low-key, the only important consideration is to hold the highlights (see Tip #19), as images can be processed darker with no loss of quality. The same is not true of opening up images when processing, as the danger is exaggerating the noise in deep shadows. For high-key treatments, expose fully. Here, the most useful playback setting is not the highlight warning, but the histogram—and the left side of it should appear well away from the left limit, towards the center.

In processing, which is not our main concern in this book, there is a full range of techniques for creating a particular key. Overall simplicity, just as when shooting, remains the goal in most shots, and whether you use levels, curves, or whatever to adjust the tonal distribution, it usually helps if you pay attention to the background and suppress features in it.

1 Somber hills and moorland bordering a Scottish loch, under thick rolling clouds, suit a low-key treatment. In fact, a more middle-of-the-road exposure and processing has little to recommend it, as the lighting is flat and there is little of striking interest in the terrain. A low-key treatment is about rich dark tones and texture.

2 White Sands, New Mexico are indeed white, and so lend themselves well to a well-exposed (could even be called overexposed) treatment. High-key implies a flood of light, as shown here.

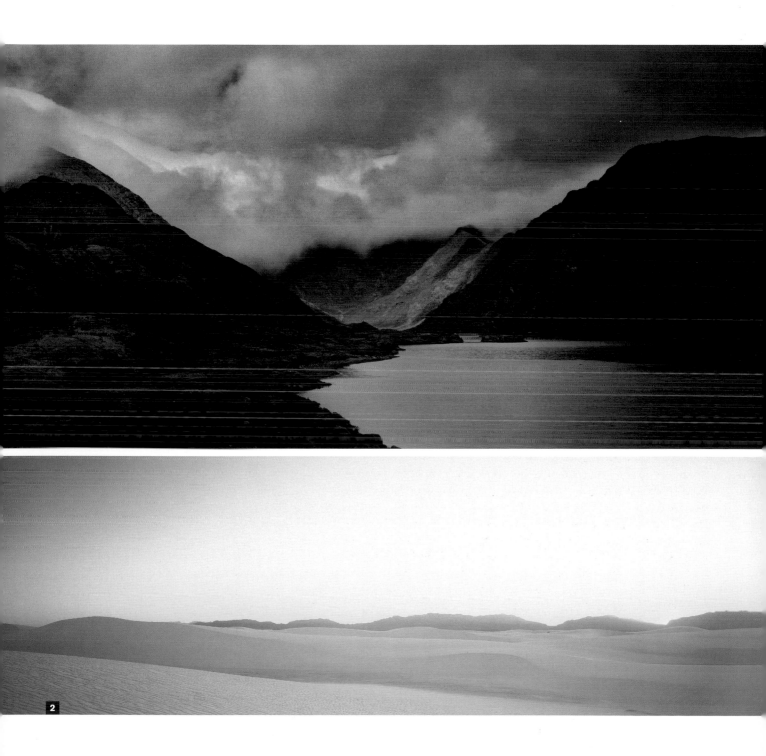

2

21

Low-process settings

All cameras offer settings that allow the on-board processor to adjust the image, typically for contrast, sharpness, white balance, and saturation. The idea, naturally enough, is to optimize the image at the earliest possible opportunity so that it is out-of-the-box ready to use. This is fine if someone really does need to use the image immediately, as would happen if you were shooting news or sports professionally. If not, realize that these settings, when used at their enhanced levels, are achieving their results by throwing information away. Increasing contrast and sharpness in particular destroys intermediate pixel values, never to be recovered. I don't mean to make this sound disastrous, because it isn't, but if the fine shades of image quality are important to you, your camera may not be the best place to tune the image.

The extent of on-board processing evolves year by year, and even varieties of local tonemapping are now offered in some cameras (local tonemapping is a class of image processing in which tones are adjusted according to what is happening in neighboring regions of the image, and is able, as in Adobe's Shadow/Highlight adjustment, to open up shadows and reduce highlights without affecting the overall brightness of the image). Yet, however useful this is for perfecting the appearance of the image as you shoot, all this is available with more controls and much more powerfully in computer software. This is my argument for preserving maximum pixel information by choosing the lowest settings

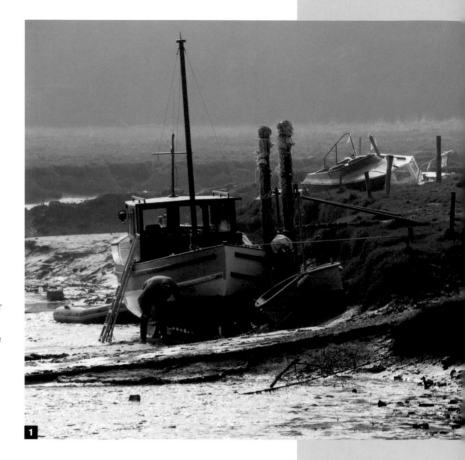

1

available. That is to say, low contrast, low sharpness, low saturation.

This is yet another recommendation for when *not* shooting Raw, as it's redundant if you *do* shoot Raw. Also, it depends on your needs and your camera, but I still find it hard to conceive of any situation in which there *is* significant post-processing needed when you *wouldn't* want a Raw file. If, however, immediacy rules, you should ignore this advice and test the settings that your camera offers, choosing the ones that give you the best visual results.

1-2 One capture, two process interpretations, either of which can be performed in the camera or on the computer. The difference is that the low-process version contains more tonal information, which means you can go from this to the higher-contrast result easily in post-processing, but not so well from the higher-contrast to softer.

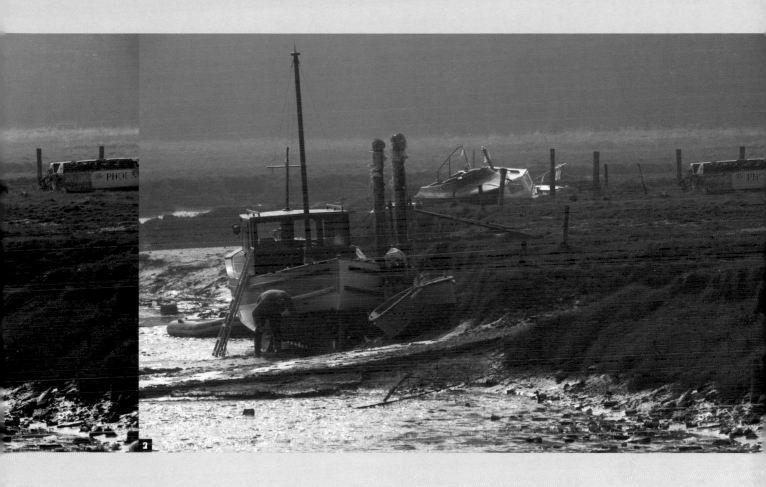

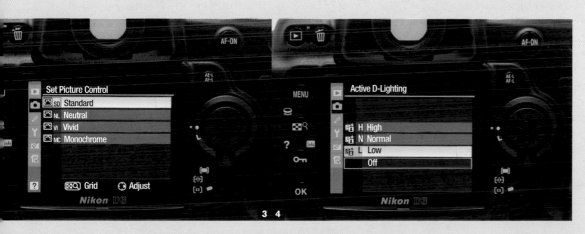

3-4 Camera models vary in the process settings that they offer. In this case, a Nikon D3, one option is a choice of presets for sharpening, contrast, brightness, saturation, and hue. The other is to apply local tonemapping to adjust shadows and highlights. Admirable though these are, I still believe that the best place for this kind of work is the computer, and the best time later, without rush.

22

A touch of flash

And I do mean a touch. Flash has its place, and in the studio or in any controlled-lighting shoot, flash can create atmosphere as well as its more mundane task of simply illuminating things to make them clear. But the march of technology in digital photography has made shooting naturally and unaided in low light a new and refreshing possibility, and this leaves full-on camera-mounted flash without very much of a purpose. You might like the effect, and it has certainly been around for years, though more in amateur snapshot shooting than in professional work. But the ability to add a carefully limited dose to an otherwise ambient-light photograph is easy enough with a digital camera, and useful. Its effect can be checked immediately, which helps in fine-tuning the result.

The details of the settings are in the manual, and I've no intention of going through them step by step here. It's not particularly complicated, anyway. The idea is to add a fraction of full-strength flash (what would be needed to light the scene on its own) to a regular exposure based on the ambient lighting. A quarter, for example; it depends on your taste. There are three broad reasons for doing this. One is in backlit situations, when it would help to have some extra light coming from your position. Another is when the overall lighting is a little sad and lifeless, as on a dark cloudy day, when you feel the need to brighten things up. A third is in very low light situations, when a time exposure captures streaked motion blur, and flash will add a frozen moment at

the end of the exposure. This last is the well-known rear-curtain flash, in which the flash is programmed at the very end of the time that the shutter is open.

I have to admit that to quite a number of photographers, flash is anathema, destroying the sense of lighting that already exists in the scene. A photographer friend of mine, Chien-Chi Chang, once called me on a cell phone when I was in the middle of the Gulf of Thailand, shooting on a fishing boat, to remind me that "Cartier-Bresson says, 'no flash'!" I did anyway, and this is the result.

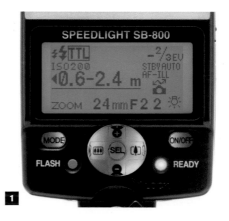

1

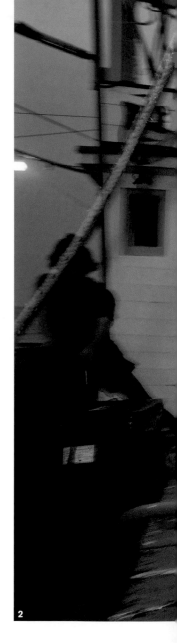

2

1 The back panel on this camera-mounted unit displays the flash level in the top right corner. Reducing the level, here by 2/3 EV, prevents the flash from dominating the shot.

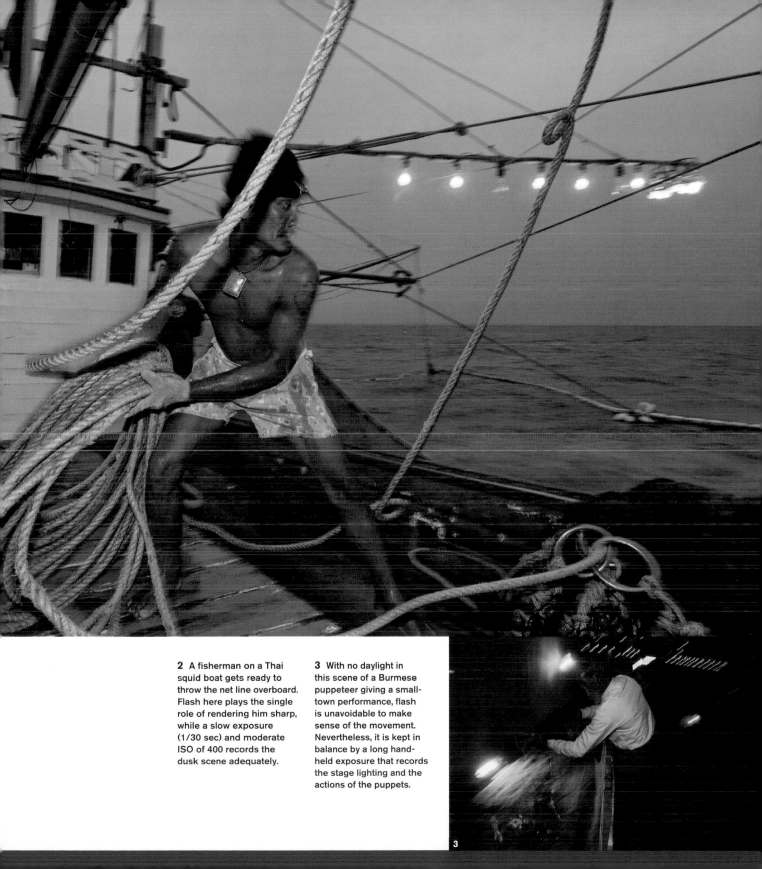

2 A fisherman on a Thai squid boat gets ready to throw the net line overboard. Flash here plays the single role of rendering him sharp, while a slow exposure (1/30 sec) and moderate ISO of 400 records the dusk scene adequately.

3 With no daylight in this scene of a Burmese puppeteer giving a small-town performance, flash is unavoidable to make sense of the movement. Nevertheless, it is kept in balance by a long hand-held exposure that records the stage lighting and the actions of the puppets.

3

23

Backlighting solutions

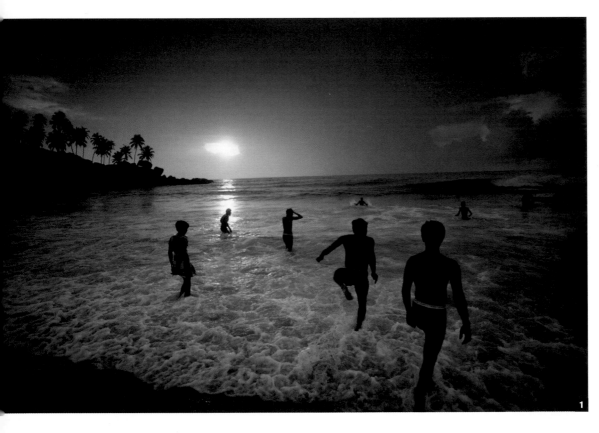

1 If the foreground shapes work, meaning if they are distinct and either read well or are interesting, let them go to silhouette, and expose instead for the often rich colors of the backlighting.

Flash, as on the last pages, is one solution for backlit scenes, but by no means the only one. There are various ways of dealing with backlit scenes, including using the situation positively rather than treating it as a problem to be solved. Basically, all are variations on five approaches, as follows:

* Use a reflector (or indeed flash) from the camera position to fill in the foreground subject
* Treat the subject as a silhouette and compose for shapes

* Ignore the highlights, let them flare, and expose for the mid-tones in the foreground. This works better in some situations than in others, and largely depends on how dominant the bright background is
* Open up the shadows in Raw conversion or in post-processing, digitally
* Take a range of exposures and use either blending or HDR techniques (see Tip #77 for this)

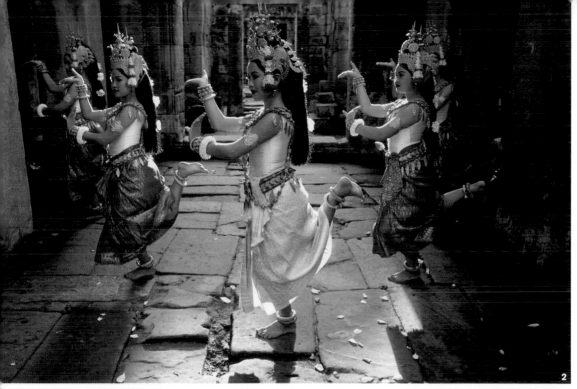

2 Here, the old temple's stone columns and doorways modified the backlighting, so that the sun was not visible. This made it easier to allow the highlights, of which there were not many, to blow out. The white satin of the foreground costume also made this easier to achieve.

3-4 Post-processing of this scanned film transparency salvages a remarkable amount of detail, using Photoshop's Shadow/ Highlight tool.

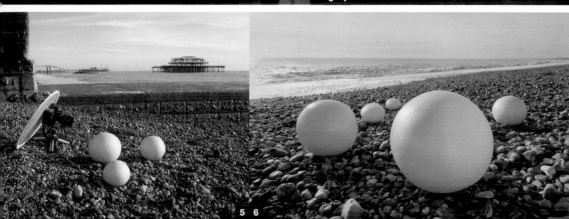

5-6 A flexible silvered fabric reflector, which folds into a neat small circle when not in use, made the ideal shadow-fill for this shot of painted stone objects by artist Yukako Shibata.

24

Reliable portrait lighting

Background

Maxilite Reflector and Barn Doors with 250Ws head set to F7.

Model.

80cm Reflector Disc.

Maxilite Reflector and Honeycomb suspended on boom arm with 500Ws head set to F7.
Main Light.

60 x 80cm Softboc with 250Ws head set to F7.
Fill Light.

Camera – Nikon D2X with 85mm lens.

1

There are many ways to light a portrait, including not bothering. For instance, strong spotlighting, whether provided by a studio light or from sunlight through a doorway, can be dramatic, as well as highlighting skin texture (wrinkles like crevasses, pores like small craters). But not surprisingly, most people sitting for a portrait actually want to look good. In fact, if at all possible, better in the photograph than in real life.

Professionals who specialize in beauty and fashion photography use an armory of lighting equipment and carefully honed techniques to create an identifiable style. Nevertheless, if you come to portrait photography without such total dedication,

a few principles will help you achieve reliably acceptable results. The three main things to remember are to place the main light frontal, keep shadows soft, and use plenty of shadow fill.

* Use studio flash lighting for full control
* Use a main diffused light over and close to the camera to avoid harsh shadows
* Up to a point, reflectors can substitute for fill-lighting, saving money
* That said, multiple lighting, including backlights, hair lights, and kickers, are a hallmark of many high-end fashion and glamor photographers
* Place a strong (metallic) reflector close beneath the face to fill chin and nose shadows. Aluminum cooking foil is an acceptable substitute; crumple and smooth for more diffusion.
* Secondary lights aimed from behind at hair and the edge of the head help "lift" the overall effect
* A small bare light from near the camera adds catchlights to the eyes

1&4 Soft frontal light helps to create a soft glow on the frontal planes of the face, moving gently to shadows on the side planes. A silver reflector was held immediately under the face to lift potential chin shadows. The white background was lit separately.

2 Large softboxes or softlites are reliable diffusers. A more advanced technique, not shown here, is to cover the central lamp with a honeycomb diffuser instead of cloth, for more obvious catch lights.

3 Collapsible fabric reflectors are available in a variety of finishes, including silver, gold, and white.

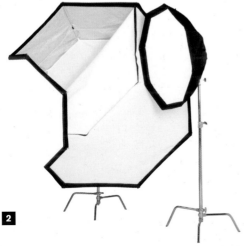

2

3

4

25

Reliable product lighting

As with portrait lighting, there are as many styles as there are photographers, but for efficiency and pleasant acceptability, it's hard to go wrong with one basic approach—enveloping light with a little directionality. Shadows are then soft and minimal, while any reflecting surfaces in the object look smooth because they reflect a large light source rather than complex surroundings.

The easy way to achieve this, even though it takes a little while to set up, is to surround the object with diffusing material and aim one main light through this from a three-quarter high position, ideally adding one or two secondary lights. One tip that I recommend highly, although it takes considerable extra effort, is to add one diffuse secondary light from below. If you remember what a light box used to look like (for viewing transparencies), this is an ideal base lighting effect. It adds immensely to the professionalizm of the shot.

* Use studio lighting for full control (and flash for comfort and accuracy)
* Use either softbox diffusing heads over the lights, or fix diffusing material around the object like a partial tent and aim lights through this
* For diffusing material, use opalescent Plexiglas, white fabric, or thick tracing paper
* Use a main diffused light over the object, either directly overhead or in a three-quarter position
* Use secondary diffuse lights or reflectors from the sides
* Place the object on a diffuse base and light that from beneath
* If you have enough lights, light the background separately

1 Strong use of the light table with a relatively high level of base lighting, on a Japanese ikebana basket.

2 Reflective surfaces, such as this Faberge cigarette box, respond well to fully surrounding diffusion.

3-4 A proprietary make of light tent, the Cunelite, maintains its shape with sprung hoops. Positioned here over a light table, it needs little more than a single bare lamp to deliver good modeling and diffusion. The front panel can be closed and the camera aimed through an adjustable zipped opening for full-surround diffusion, which is useful for highly reflective surfaces.

5 A light table, used in conjunction with the diffusing material, allows light to flood upwards from a floor lamp.

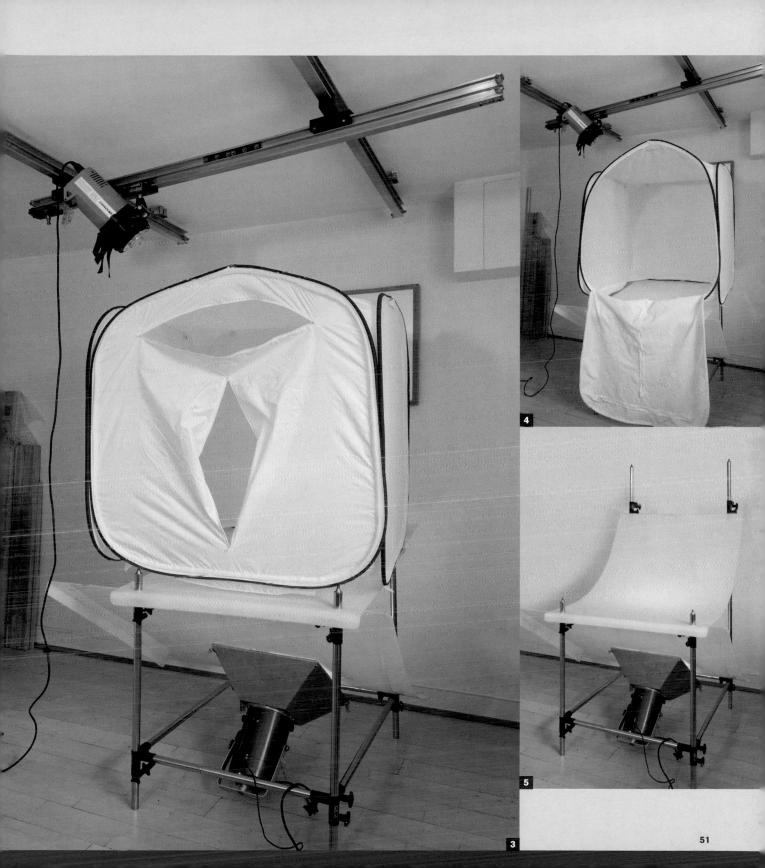

4

5

3

Chapter_

03

Color

31 32 33 34

26

White balance made simple

3

White balance is simply digital jargon for getting the color of the overall lighting to look "normal." The reason why it is needed, and why it puzzles many people at the beginning, is that our eyes do far too good a job of adapting to different colors of light when we look around us. Generally, we hardly notice the differences between daylight, incandescent light, and fluorescent light, to name just three. Yet the differences are real, and the camera sensor with its colored mosaic filter records them.

Interesting though it may be to study color temperature, it's unnecessary. Most artificial lighting these days isn't even *on* the color temperature scale, and is only given a Kelvin rating to make comparisons easier. What counts is how far the lighting is from white, and in what color direction. White is considered normal because that's the way our eyes have developed, and the definition of white is midday sunlight. The camera's white balance menu offers various ways of making any light conditions appear white, hence the name. The most common way is to choose from the list of lighting situations, but there are other, more specialized ways that we'll come to shortly.

Now, white light generally looks right, but it's easy to overdo. The white balance that works for you is whatever you like the look of. Having an overall color cast can be good for a picture—just think of a late afternoon scene bathed in golden light, which most people would prefer to a "corrected" version. If you like the effect of an overall color cast, stay with

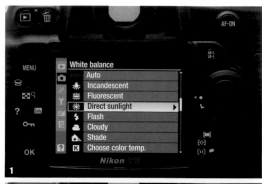

1

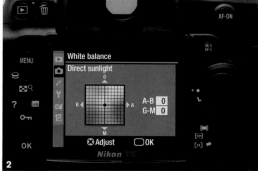

2

it. If you need a whiter rendering, choose from the menu. Remember that color casts can always be adjusted later, on the computer, with only a little loss of image quality. And, there is a huge advantage in shooting Raw (see Tip #3), as this keeps the color settings separate, which means you can choose the white balance later with absolutely *no* loss of image quality. If you shoot Raw, it doesn't matter what white balance you choose in the camera at the time. Personally I shoot using the Auto white balance most of the time.

1-2 A typical white balance menu offers these choices, and they can often be refined by hue in a second-level control.

3-5 White balance choices are self-explanatory, but there is still room for personal taste. The color temperature differences between sunlight, cloud, and shade are evident here in three versions of a coastal scene on a sunny, but slightly hazy day.

6-7 Balancing for fluorescent lighting is trickier than for other light sources, as it varies and is fairly unpredictable, involving not just color temperature, but hue. It is worth experimenting with the Auto setting also. Here I shot Raw so I could precisely fine-tune the white balance.

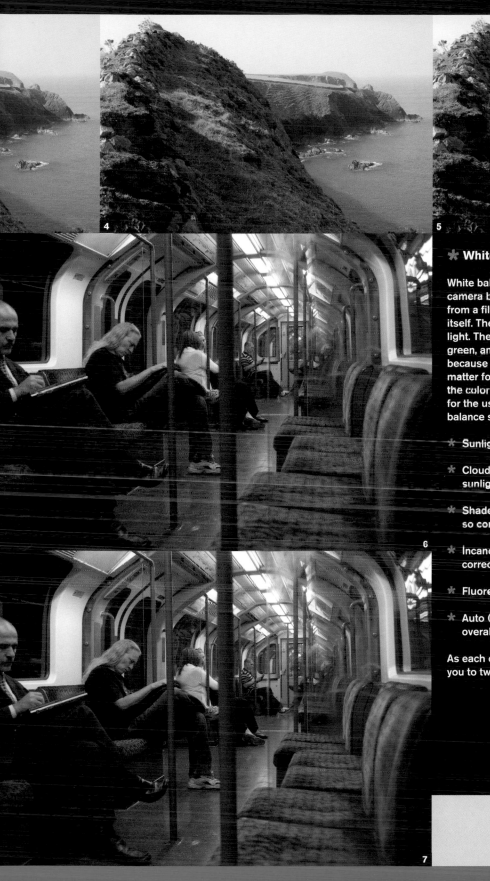

✳ White balance in the camera

White balance is easy to select and adjust in the camera because all the color information comes from a filter in front of the sensor, *not* the sensor itself. The sensor measures only the quantity of light. The Bayer array is a checkerboard of red, green, and blue that adds the color information, and because this is done pixel by pixel, it is a simple matter for the camera's onboard processor to alter the color information digitally. To make things easy for the user, cameras offer a set of common white-balance settings. Typically these are:

✳ Sunlight (sometimes called daylight)

✳ Cloudy (which is very slightly bluer than sunlight, so the camera corrects for this)

✳ Shade (meaning open shade under a blue sky, so considerably bluer than sunlight)

✳ Incandescent (distinctly orange, so the camera corrects for this)

✳ Fluorescent (very variable, but typically greenish)

✳ Auto (the camera does its best to avoid any overall color bias)

As each of these is variable, most cameras allow you to tweak the settings.

27

Look for the gray

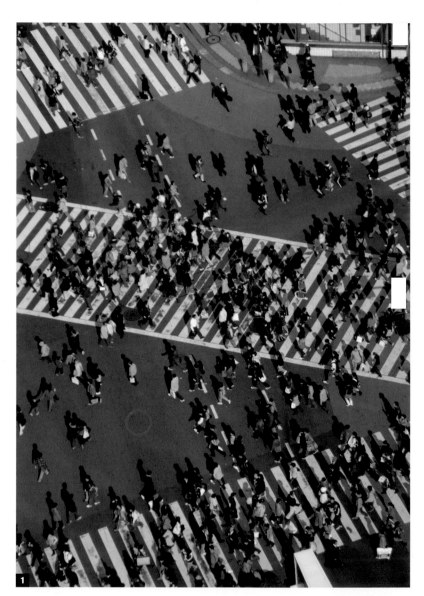

As we've seen, the white balance in a photograph can vary from being unimportant to critical, depending on the subject and on your needs. Recognizing this is the first step. For the times when it *is* important, there are at least two ways of guaranteeing perfect accuracy—using a color target, and setting a customized white balance. For the times when it's quite important, but you're in a hurry to shoot, there's this simple solution—find and make a mental note of one area in the scene that you know should be a neutral gray. Then, whatever else you do, at least you have a reference that you can work on later in post-processing.

Naturally this works best if you shoot Raw, as all white balance decisions can then be deferred until later. But it still works if you shoot and save JPEGs or TIFFs. All image-editing software, from Photoshop to the simplest, have some form of gray dropper or sampler—a cursor that will color-shift the entire image around any point that you select to be neutral.

Not all scenes have a neutral point by any means (a typical sunset, for example), but these tend not to be color-critical in any case. Also, beware of over-correcting scenes in which the color of the lighting is attractive or contributes in some way, such as a landscape lit by a low sun, or a domestic interior at night that you want to look warm and inviting.

But for the average run of scenes, the following are potential gray points: concrete, steel, aluminum, car tyres, asphalt, thick clouds, and shadows on white (as in the folds of a white shirt, or on a white wall, but there is also a risk of these picking up colored reflections). If your shot contains one of these, good. If not, look for—and remember—any surface that is approximately neutral.

1 Roads, asphalt, and sidewalks are useful. While never guaranteed neutral, visually they are usually close enough to be a workable reference.

2 3

✳ Gray point, gray card

You can always bring your own "gray" for setting the white balance. A standard 18% reflectance gray card is useful to carry around, although for formal planned shoots rather than reportage. It gives a standard reference for neutral, and also a reference for mid-tones. Nevertheless, if it's worth the effort of pulling out a gray card and making a test shot, you might get better value from a color target (see Tip #28).

4

2 White paint tends to be neutral, but when using a gray dropper it is better to select a shadowed area. This runs some risk of color shift because it is influenced by the color of the skylight, but you can factor this in visually.

3 More shadows on white, but see here that there are variations in the "white" paint, plus the added shift caused by a setting sun. A solution here would be to choose the white cotton fabric and then manually adjust the color channels in Curves or Levels to warm it up.

4 Visually gray clouds are also acceptable as gray reference points. As with all these ad hoc "grays," it's best to use them as a starting point, and be prepared to tweak the color a little in post-processing.

28

Color target for total accuracy

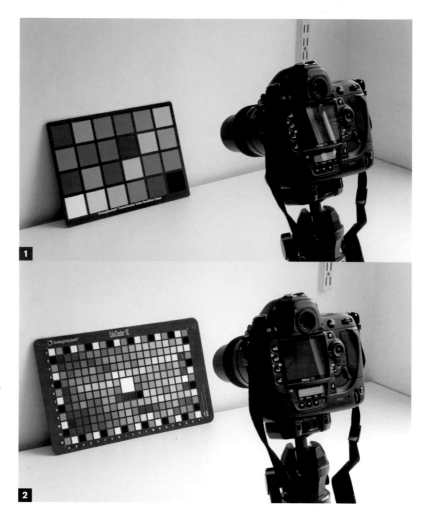

1-2 There are two standard targets, both from GretagMacbeth—the original 24-patch target and the newer, more complex one designed for digital photography.

If clicking on gray brought all the other colors into line, life would be simple indeed. But, as you may have discovered already by trying the advice from the previous pages on a variety of images, it does not always work like that. Shifting everything to follow one color direction can result in some colors not being quite what you expected or wanted, and the greater the shift the more likely this is.

But in addition there is the more difficult problem of metamerism. This is when two colors look the same under one light, but different under another, and in photography this is often an issue with fluorescent and vapor lighting. Practically speaking, some colors don't appear as you think they should when you shift the white balance.

The solution is a little time-consuming, but well worth it if you absolutely need perfect color rendering across the spectrum, as you might with an interior, or reproducing a painting, or fabrics. In exactly the same lighting as you are shooting in, take one picture of a standard color target. This essentially means a GretagMacbeth ColorChecker, which contains hand-prepared color swatches. Photograph it large in the frame, face-on, and at an average exposure setting. Ideally, the white patch should register around 245 on the 0-255 Levels scale, and the black patch around 50.

Later, use profiling software to create a profile for these exact lighting conditions. This is not the place to go through the procedure step by step, but the procedure is straightforward and involves

opening this image, aligning the image of the target with a grid, and saving the profile created so that you can apply it to any picture taken under the same conditions. The software used here is inCamera, a Photoshop plug-in.

A warning: using a color target works only if the *whole* scene is lit by the same color of lighting. Why would it not be? Many reasons, not all obvious to the eye, which has a wonderful ability to accommodate to shifts in color. The scene may be a room lit partly by daylight from a window on one side, but by artificial lighting on the other. Your eye might be able to deal with the two sources and see little difference, but the camera sensor will see exactly the difference, which in this case is considerable, in the order of 6,000 K.

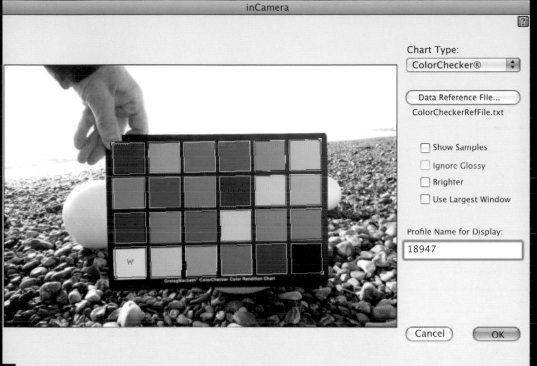

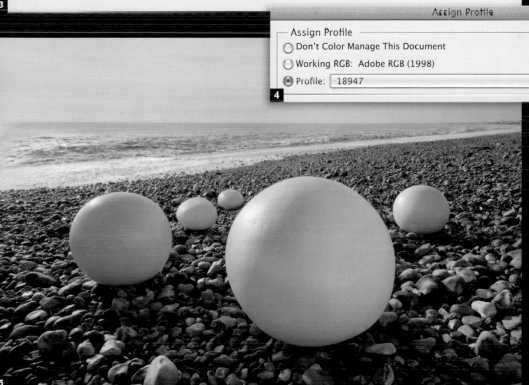

3-5 In use, photograph the card under the same lighting as the real shot, at approximately average exposure, then use the software to construct a profile from this. A grid overlay can be distorted and scaled to fit the image.

29

Custom white balance

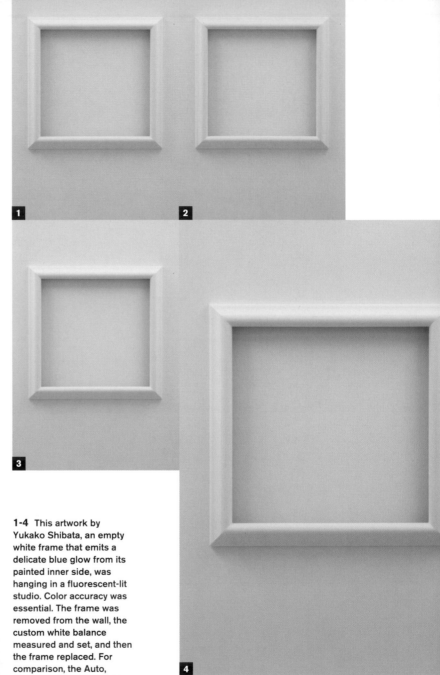

Most SLRs offer a custom white balance option, in which the camera is used to measure the color from a white surface in the same lighting. When there is a readily available white surface, as in the example here, this is the easiest completely accurate method. White surfaces are, in any case, usually easy to come by in many situations—think white cloth and white paper. It can also be used with a standard 18% gray card (see Tip #27), but if you are going to the trouble of carrying a target around with you, it might as well be a ColorChecker.

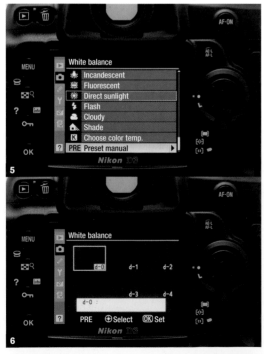

1-4 This artwork by Yukako Shibata, an empty white frame that emits a delicate blue glow from its painted inner side, was hanging in a fluorescent-lit studio. Color accuracy was essential. The frame was removed from the wall, the custom white balance measured and set, and then the frame replaced. For comparison, the Auto, Fluorescent, and Daylight options show how critical the difference can be.

5-6 Here, on a Nikon, it is called Preset manual. Once activated, the camera is aimed at a white surface—paper, painted wall, card, cloth—and this white balance is calculated and stored for all future shots.

30

Check on a laptop

Even if you don't care for the idea of shooting tethered, there are times when it helps to see an image on a decent-sized and color-calibrated screen soon after shooting, when you have the chance to compare it with the actual scene. This is not even an issue of re-shooting, but rather of being able to judge color accuracy on the spot. Good though some camera LCD screens are, they come nowhere near a calibrated display.

For the general run of photography, color is not that critical, and if you are shooting in a studio under photographic lighting you would probably have the camera tethered to a computer anyway, but location shooting sometimes throws up situations where precise color is needed, yet tricky to judge. A location fashion shoot is one example, another is the example here, a stained glass window with strong, definite colors. Even if the light source is known fairly well—in this case a cloudy day in the region of 6,500 K—the pigments or dyes in different surfaces may not record digitally just as we see them. These are wavelength and response issues. Here, even though the white balance was set to Cloud, the unadjusted result was wrong for several colors. The tiger was more red than brown, and the green strips were too yellow. As the shots had been taken in Raw, there was no reason to re-shoot, but making a visual match while processing with a Raw converter (in this case, DxO Optics Pro) involved a series of adjustments and was anything but simple.

Key to all of this, naturally, is a properly calibrated screen. There are several ways of doing this, from eyeballing to using a colorimeter, and you should follow the manufacturer's instructions. Display quality varies, and many laptops suffer from a limited angle of view. You should compare the results once you have calibrated the screen with that on a desktop display, and decide if they are close enough for you to rely on.

1-2 Backlit stained glass would be difficult to calibrate by any of the usual methods, but what was in any case important was a close visual match. Comparing the just-shot images with the window made it possible to guarantee this on the spot.

31

Impact from color contrast

Color in digital photography is much more than simply getting the overall balance "right," or as expected. Like composition, the choice and handling of colors in an image can be creative, surprising, and elegant—in fact, it can be a major component in the success of a photograph. Like composition (as discussed in Chapter 5), advice on color runs the serious risk of being formulaic and trivial. It's certainly true that complementary colors, such as orange and blue, create a feeling of harmony when they appear together, but it is also predictable. Moreover, being harmonious and balanced is not the single goal of making images. Discord can be more striking. Intention and taste, as always, are the most important factors.

A distinct contrast between two or three strong, saturated colors, is one certain way of catching attention. It depends on finding the right combination, and on lighting. Strong light with definite shadows enhances our perception of vividness, as can be seen in both these examples, shot under medium-low bright sunlight on particularly clear days. Needless to say, any relationships between colors, such as harmonious or clashing, come across most strongly when the colors are intense like these. What you give up is subtlety, which is the subject of the following page.

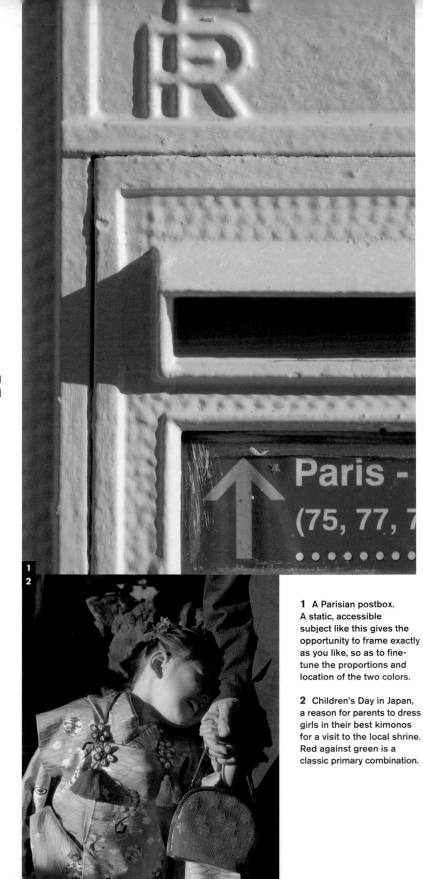

1 A Parisian postbox. A static, accessible subject like this gives the opportunity to frame exactly as you like, so as to fine-tune the proportions and location of the two colors.

2 Children's Day in Japan, a reason for parents to dress girls in their best kimonos for a visit to the local shrine. Red against green is a classic primary combination.

32

Subtlety from a restrained palette

2 An apprentice geisha, or maiko, walks down a Kyoto lane. The colors, interestingly, are essentially those of the other image, though in different proportions.

Strong colors have their place in photography, but so too do muted pastels. It's a matter of style. The search is still for combinations of two, possibly three colors that contrast, but muted scenes like those achieve their results by avoiding primary colors, using generally subdued lighting, and less saturation than on the previous page. Too much loss of saturation, however, tends to create dull and muddy colors, while pastel shades need to retain some purity.

The advantage of shooting softer colors is that it encourages a slower viewing of the picture. The actual colors are often more interesting because they are less familiar than pure primaries and secondaries, and there are more opportunities for exploring color relationships. Appreciating the subtleties takes the viewer longer, and provided that the image holds the attention, the final effect can be more rewarding.

1 Art Nouveau tiles on the façade of an old Paris café form a three-way relationship of delicate colors, made more interesting by the modulation of reflected light.

1

2

33

Unified color

We're all used to the concept of a color cast, a single hue that suffuses the image, and the various ways of dealing with it *as a problem*. These include adjusting the white balance when shooting, sometimes the hue also, or doing color correction work in post-processing. And while it's true that an overall cast can be disturbing and look like color gone wrong, there are many occasions when an overall single theme adds to the power of an image. A single color unifies the elements in an image. There can even be a sense of surprise in finding and framing a view that is dominated by one color. This was the point of the close-up image here of a mantis on rice stalks—a study in the green of things growing.

Moreover, when you arrange several images together, such as on a web page or a printed page or on a gallery wall, a range of color-themed photographs can itself create an interesting combination. If you have a set of images each dominated by a single hue, putting them together is another expression of the art of color relationships.

1 The green of young rice stalks suffuses this image, and is added to by the presence of a matching praying mantis.

2 The overall blue cast is exactly that of color temperature, caused by the blue of the early evening sky reflected by surrounding snow. It might be tempting to "correct" this by neutralizing it, but this would destroy both the sense of fading light and of the cold.

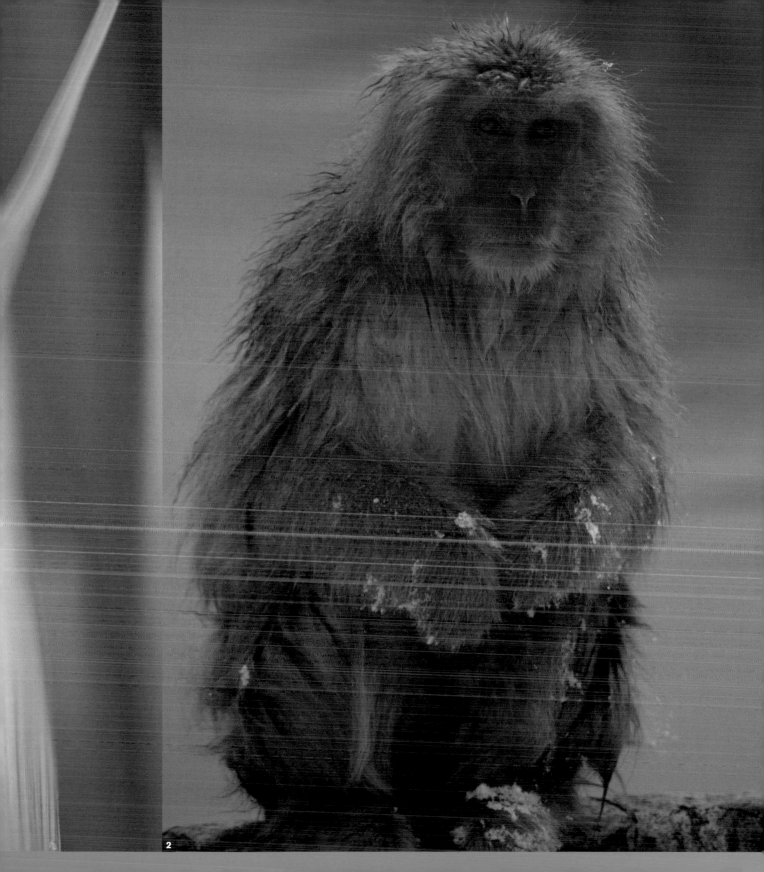

34

Shooting for black-and-white

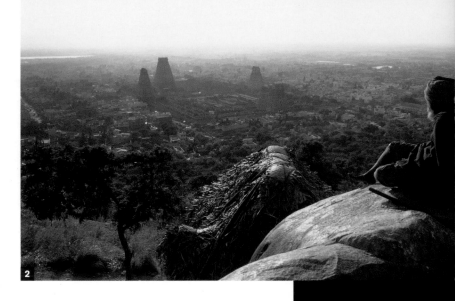

Digital capture has given black-and-white photography a new lease of life, particularly in the fine control it offers over the way in which colors are rendered as shades of gray. The mind-set of black-and-white photography is quite different from that of color shooting, and while here is not the place to go deeply into the philosophy of monochrome, it can have a profound effect on imaging. Eliminating hues elevates the modulation of tone to a position of great importance. This in turn allows considerable refinement, and the non-color elements of a picture, especially form, shape, edge, and texture, acquire more meaning. The long tradition of black-and-white within the history of photography gives it a legacy that many photographers find satisfying. Digital purists might also argue that as sensors capture in monochrome, and color is added only by the device of a Bayer filter array, black-and-white is the truer form of photographic image.

Some cameras offer a black-and-white (or monochrome) shooting mode. The RGB channels remain, but are desaturated, although can be recovered in Raw. The value of this is that it makes it easier to see what works in black-and-white at the time of shooting. Some cameras also offer the equivalent of sepia toning results.

Post-processing is where the conversion of a color file into monochrome allows you a range and delicacy of control that wet-print darkroom enthusiasts could have only dreamt of. Every editing program, from Photoshop to LightZone and DxO Optics Pro, among others, offers ways of conversion that allow the channels to be manipulated. Shown here is the black-and-white conversion dialog in Photoshop. A drop-down menu offers a number of presets mimicking the effect of traditional color filters for black-and-white.

1 Black-and-white capture is an option offered on many SLRs. Shooting in Raw, as here, gives the second chance of going back to color if necessary in post-processing.

3

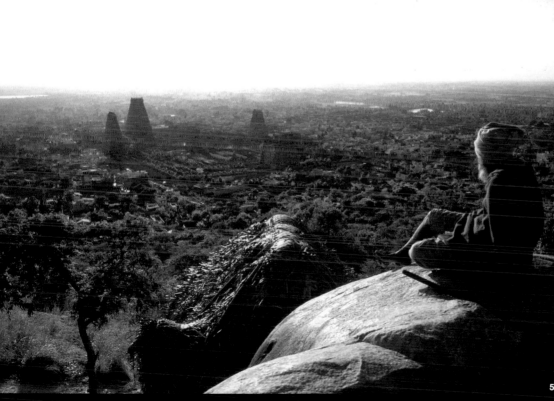

2-6 A scanned color
image and two of several
interpretations possible by
adjusting 6 color sliders. In
one, the aim is to maximize
the sense of distance and
haze with high blue and low
green. In the other, the depth
is equalized by raising the
green and lowering both
blue and cyan. Red was
kept moderate to high in
both cases.

5

Chapter_ 04

ng bank

settings

osure **35**

Take phot
featureles
10 cm fron
Focus will

36

37

38

39

Technicals

40 41 42 43 44 45 16 47 48 49

35

Customize your settings

With each new SLR model comes an increase in its capabilities, and this translates as more choices in the way it can be used. The choices involve focus modes, exposure measurement, color, and much more. While choice is good, it can be overwhelming, particularly when the idea of photography is to shoot rather than to fiddle (see the very first tip).

A case in point is focus. There are now some very sophisticated automated techniques that can include scene recognition (being able to distinguish the head and shoulders of a person and lock automatically into that) and focus tracking, which follows a subject on which the camera has locked focus. If you are a sports photographer, this is essential stuff, and immensely valuable. If you spend most of your time shooting landscapes, it would just get in the way.

One sensible way of making use of the features that *you* need, while keeping others in the background, is to customize your settings. The procedure for doing this varies with the manufacturer and model, but the basic idea is to put the settings that you use the most, or that you want to play around with the most, in a settings bank. This saves scrolling through the menus and sub-menus and hence wasting time.

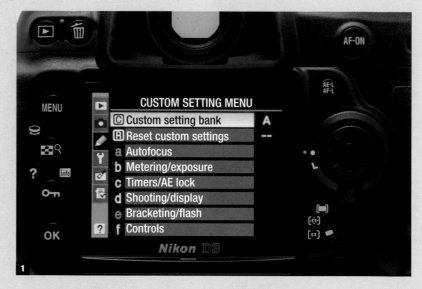

1 A custom settings bank is a location where you can store your personal selection of important settings, for rapid access.

36

Dust check

The shadows cast by dust and other small particles that settle on the sensor (or rather, on the high-pass filter that covers the sensor) remain one of the constant problems when shooting with digital SLRs. Dust is almost impossible to avoid if you change lenses in anywhere less than a sterile setting like a studio, so any form of outdoor photography is prone. Some ingenious manufacturing solutions are beginning to evolve, such as ultrasound and mechanically vibrating the low-pass filter to shake off particles, but in any case it's absolutely essential to check for dust frequently. The simplest way is to examine the image at 100% magnification whenever you know that the conditions are likely to show dust. To be more conscientious, do the following:

Fit the shortest focal length you have, or select the shortest focal length on a zoom lens. Stop the lens down to its smallest aperture. Focus the lens manually to its nearest setting and aim at any blank, pale-to-mid-toned area, such as a white wall or the sky. Expose automatically or slightly adjusted for a lighter than average result. All of this will show up any dust shadows at their worst.

Next, view the image on the camera's LCD screen at 100% magnification. Start at the top left corner and scroll along to the right, then down and back left, and so on until you have examined the entire image. Any significant dust shadows should be clearly visible as darker spots. The next step is to clean the sensor (see Tip #37), or be prepared to

✳ Conditions that show up dust

Small aperture
Closing down the lens aperture diaphragm extends the depth of focus, and this brings dust specks into sharper focus.

Wide-angle lens
The shorter focal length of a wide-angle lens gives a greater depth of field, which helps bring dust into sharper focus.

Featureless mid-tones
Scenes with little detail, like a typical sky, make dust shadows more evident. As opposed to such low-frequency areas in an image, high-frequency areas with a lot of content detail usually hide dust artifacts sufficiently for them not to need removal.

Unfocused areas
Blurred, out-of-focus areas create another kind of low-frequency smooth zone, against which dust shadows tend to stand out. However, these areas are more common with long focal lengths and shallow depth of field, and this tends to compensate to an extent.

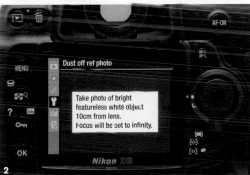

1 Follow the procedure given in the text, and at 100% scan a featureless frame from left to right and top to bottom.

2 Some cameras allow a dust template frame to be captured, which can then be used by appropriate software to perform dust removal from a batch of images.

remove the shadows in post-production. Some cameras use a similar procedure to create a "dust template," which can then be used for a kind of automated batch removal.

37

Clean your own sensor

This used *not* to be recommended, because of the risk in unskilled hands of scratching the surface of the low-pass filter. That was fairly reasonable in the days when camera manufacturers cleaned sensors without charge. Nowadays, however, cleaning costs are quite high, and there are DIY cleaning kits on the market, so cleaning your own sensor is more or less necessary. If you are careful and confident, it also means that you can take care immediately of any fresh invasion of dust. Note that camera manufacturers still advise against DIY cleaning, but that is to protect themselves.

The big divide in sensor cleaning is between not touching and touching the surface. The simplest procedure is to use a bulb blower that you squeeze to direct a jet of air from its nozzle. As long as you avoid touching the surface of the sensor with the nozzle, no harm can come from this. However, blowing into the camera also has the effect of just moving the dust around rather than extracting it, and while you can remove dust from the sensor, it is likely to remain in the box and can settle back again at any time. Follow the camera manufacturer's instructions closely for exposing the sensor, which involves locking the mirror up and opening the shutter with the lens removed. Find a clean, dry area with no air movement, and settle yourself comfortably so that when the camera is turned face up and the sensor exposed you have good access to it—such as on a desktop. A sharply focused light is essential, and while the usual procedure in the field is to use a small flashlight

1-2 Follow the menu instructions for locking up the mirror. This needs at least a full charge in the battery, and on some models a direct AC power supply.

(high-powered LED lights are good), it's even more convenient if the light can be fixed so that you don't need one hand to hold it. Once you have a good view of the sensor, move either the light or the camera from side to side so that it reflects the light across the surface. Use the blower firmly, but watch where the dust goes. Needless to say, never blow with your mouth, as drops of saliva will need serious cleaning.

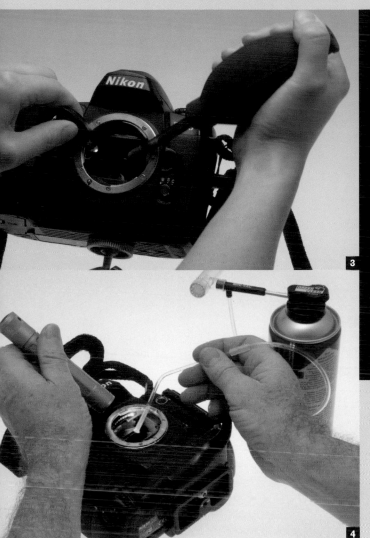

If you are cleaning the sensor because you just did a dust check, look for the specific dust shadows. The lens, of course, inverts the image left to right and top to bottom, and as you are looking down into the throat of the camera, what you will see is the dust pattern flipped both ways. In other words, a speck of dust that you saw in the top left corner of the most recent image will actually be in the bottom right corner of the sensor as you look into the camera.

A much better non-invasive (that is, not touching) method is with a small vacuum cleaner. Some dust removal kits include this, powered by a can of compressed air. You need to be more careful than with a blower because the suction effect is not as powerful and the head of the cleaner needs to be held very close to the sensor.

Any dust that resists either of these methods needs to be lifted off physically, and this is the last resort. Resist the temptation to use a small brush, because unless it is absolutely sterile, you will add smears. Use a sensor cleaning kit and follow the instructions to the letter. Typically, it involves opening a sealed, sterile wet wipe and gently wiping this across the surface. There are also dry-wipe kits.

3 Standard for the camera bag is a blower and a flashlight (a small white LED is convenient). But a blower is unlikely to remove particles from the chamber.

4 A miniature vacuum cleaner powered by compressed air does a more reliable job of removing particles, rather than just pushing them around.

38

100% sharpness check

Getting the subject sharply focused is such a basic skill that it tends to be overlooked in the examination of other image qualities, such as white balance and highlight preservation. Yet it is arguably the most important quality of all. Many other mistakes are recoverable in post-production, but even a modest loss of sharp focus can make an image worthless. If you are aiming for impressionistic and experimental results, then fine, but for straightforward shooting, pin-sharp focus in the key area of the image is an absolute necessity.

I wrote "basic skill," but these days few photographers use manual focusing, much less a manual lens, which means that focusing is normally in the realm of automation. This, however, does not eliminate mistakes. In auto-focusing, the most common error is targeting the wrong part of the scene, such as the background in a portrait. Advanced cameras use a variety of methods for finding and keeping sharp focus on a key subject, including scene recognition, but nothing is foolproof. A more subtle error is focusing on, say, the nose rather than the eyes in a close portrait with shallow depth of field. The wider the aperture, as is usually necessary in low-light shooting, the more this is an issue.

The second most likely class of sharpness failure is motion blur, either camera shake because of a slow shutter speed, or subject movement. I deal with some of these things in more detail in the Low-light chapter, but ultimately the key precaution is to

check, and as soon as possible after the shot. No one expects to do this all the time, but if you know that the shooting conditions are risky, this is the time to pay special attention.

Paradoxically, the camera's LCD screen and its image preview that makes life so much easier and more reliable than shooting film, can also lull you into a false sense of security when it comes to image details such as sharpness. This is a real danger, and despite experience I've fallen prey to

1-3 Zoom in the full amount to examine any detail with high-contrast edges.

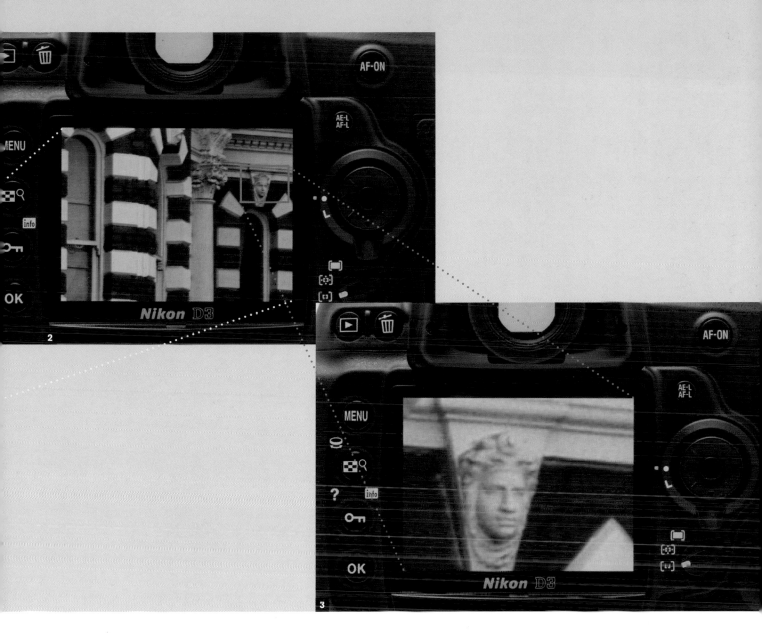

it a number of times. You glance at the screen, it looks fine at that size, so on to the next shot. The bad moment arrives in front of the computer when the images are being processed. And by then it's too late.

In fact, it's impossible to judge sharpness from a full-screen view on the back of the camera. The right thing to do is to zoom in to at least 50%, and ideally 100% magnification. Pan around the image if you have the time, but at least home in on the area that you intended to focus on. In many situations, you have the opportunity to re-shoot and get it right.

As for achieving pin-sharp focus, there are a variety of in-camera aids specific to each model. High-end cameras have sophisticated procedures such as multi-point focus and focus tracking. There may also be a choice between autofocusing methods; phase-detection uses a special focusing sensor, while contrast-detection analyzes information from the image sensor.

39

Repairing poor focus

What if you failed to make any of the sharpness checks just described and are faced with a soft image? Or at least soft where it counts? Yes, there *is* a software solution, up to a point. Standard USM (Unsharp Mask) sharpening is not much help, as it doesn't address the root cause, but instead tries to fix things by heightening the contrast across a few pixels. You might get some apparent improvement by applying some USM sharpening to selected areas only, but this kind of sharpening becomes obvious and objectionable when used even slightly aggressively. What's needed is software than can calculate the exact amount of focus blur and then attempt to restore it. De-blurring software, in other words. The procedure is called deconvolution, and involves finding the amount and shape of the original blur, then reconstructing the image by reversing the blurring. It is process-intensive and complex, and while de-blurring receives considerable attention in research papers and for security uses, there is very little available commercially. Photoshop has a filter that attempts this (Filter > Sharpen > Smart Sharpen, then either Focus Blur or Motion Blur), but dedicated software appears, at least on my tests, to perform more effectively. One plug-in that works well in many situations is FocusMagic, which includes a function for estimating the amount of blur (this is measured in pixels). A warning, however—the maximum softness of focus that is correctable is in the region of about 20 pixels.

1-3 A focus mistake in which the lens aperture was wide, so gave a shallow depth of field, and the point of focus was the wall behind the receptionist. Focus was repaired using FocusMagic, a Photoshop plug-in, on a duplicate layer. The upper, original layer was then selectively erased around the face, so that the deconvolution repair, which tends to be quite aggressive, did not damage the well-focused wall details.

4-6 Motion blur can also be tackled by the same software, and the results are often more striking, as doubled and streaked features spring back into recognizable features, as with the facial ornaments of this Sudanese woman.

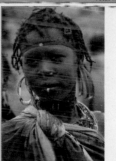

2

Focus Magic – Registered to Michael Freeman

Before After

Image Source	Digital Camera	
Blur Width	Detect	10
Amount	100%	
Remove Noise	Auto	

Register OK

About Cancel

3 Noise Removed = 0.0%

4 5

Focus Magic – Registered to Michael Freeman

Before After

Image Source	Digital Camera
Blur Direction	0
Blur Distance	20%
Amount	100%
Remove Noise	No

Register OK

About Cancel

6 Noise Removed = 0.0%

40

Really sharp focus

Like many image qualities, sharpness is something most photographers take for granted. It's focused or it isn't. Well, it's not quite as simple as that. How sharp is sharp? The answer is, it depends what you're used to. Autofocus has a very high success rate, but still relies on being pointed at exactly the right spot, while lenses definitely vary in how good their resolution can be. An old rule of thumb is that the best resolution is at about two *f*-stops less than maximum, and it usually holds true. Stopping right down loses resolution because of diffraction effects.

Make a habit of checking sharpness, as on the previous pages. But even more importantly, spend a little time finding out how sharp you and your lenses can actually focus. Do two things. First, take a lens that you can set to manual focus, and aim at something that will give you a good, clear detail at 100% magnification. At maximum aperture, focus as sharply as you can on that detail. Then alter the focus by the smallest amount that is physically possible, and shoot a second frame. Move the focus again and shoot, two or three more times. Examine the results. Next, take all your lenses and photograph the same detail at the same size; this involves moving the camera viewpoint backwards or forwards. Include different zoom settings on a zoom lens. Compare the details.

You might be surprised to find from both of these tests that there are fine differences between what you would ordinarily call "sharp." Reasonably sharp is one thing. Pin sharp is another. It pays to set your standards high.

Digital sharpening is not at all the same thing as sharp focusing. It is a post-capture filter that enhances the impression of sharpness by increasing the contrast between adjacent pixels. That's something of an over-simplification, but gets the idea across. If you look at a slightly soft edge strongly magnified, what you are likely to see is an intermediate pixel or two between the dark side of the edge and the bright side. If the edge were black against white, for example, a line of gray pixels in between would come across as a little soft. Digital sharpening exaggerates the contrast, and in this case would remove the gray. There are many software versions of sharpening, USM (Unsharp Mask) probably being the best known, but none of them can magically restore detail that was lost by failure to focus exactly. There is, however, a procedure that will do this to an extent, called deconvolution, which attempts to analyze how the focus got blurred in the first place, and then reverse the process. The example here is an application called FocusMagic. But there's nothing like getting really sharp focus in the first place—this is a special image quality in its own right.

1-2 Minute changes in manual focus on an 85 mm lens at full *f*1.4 aperture (moving front-to-back, left-to-right) make it possible to judge the peak of sharpness with this particular lens. The point of attention is the figure III on the angled clock face.

3-4 A notably sharp lens on a subject with high-contrast detail—fine black hairs against a face.

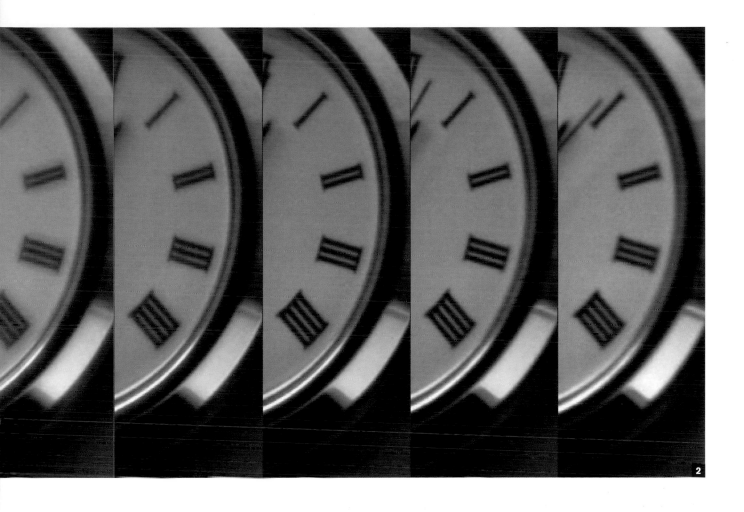

41

Know your steadiness limit

In low-light conditions, or when you are trading a smaller aperture for shutter speed for improved depth of field, you ought to know what the chances are that you are capturing an acceptably sharp image. Important though it is to keep checking the sharpness at magnification on the camera's screen, it's impractical to do this after every shot, particularly if you are getting a high rate of failure. The sensible solution is to test your ability to hold the camera steady *before* you have an urgent need for it, and plan accordingly.

Camera shake is a fact of life, and what matters is whether or not the image moves sufficiently during the time the exposure is made to be noticed. There are degrees of sharpness, and acceptably sharp may be less than perfect (pin-sharp), yet still be OK. There is also a matter of the percentages. In between the speed at which you can be sure of getting it sharp every time and the speed that is definitely too slow, there is a range of speeds at which you might get it right some of the time, meaning that if you shoot more frames you are more likely to get at least one good result.

The two technical variables are the shutter speed and the focal length. The latter is important because it affects the magnification of the image. Longer focal lengths magnify, so they also magnify the effects of camera shake. An often-quoted rule of thumb is that the safe slowest shutter speed is the reciprocal of the focal length, or $1/\text{focal length}$ (in mm). This translates to shooting with a shutter speed of

at least 1/100 sec with a 100 mm lens, although a simple practical experiment will show that unless you have some special limiting condition, this is way too conservative.

Make the test under convenient, controlled, and repeatable conditions, such as at home. The target should be some object with finely resolved detail, like an optician's test target, a clock-face, or a page from a book or newspaper. With the lens you use most often (setting it to the far end of the range if it is a zoom), take a series of shots that begin with a completely safe speed and get slower. For completely safe, choose twice the focal length as a speed, such as 1/200 sec with a 100 mm lens. This removes all doubt and you can use this exposure as a benchmark for comparison. For the subsequent exposures (in this particular case 1/100 sec, 1/50 sec, 1/25 sec, and so on), take several frames in quick succession. As I mentioned, when you reach the critical speeds, you may find that one out of a few blurred shots is acceptably sharp.

Download the images and examine them in your usual browser or database, ideally at 100% magnification and side-by-side. Note not just the completely safe speed, but also the speed at which you stand a chance of being sharp by shooting a few frames. Now you know. Repeat the test with other lenses and focal lengths.

1 Using a browser (Photo Mechanic) at full magnification, clicking through a sequence of images highlights the differences between them.

2 According to my personal classification, from left to right: pin sharp/sharp enough/almost sharp/significantly blurred.

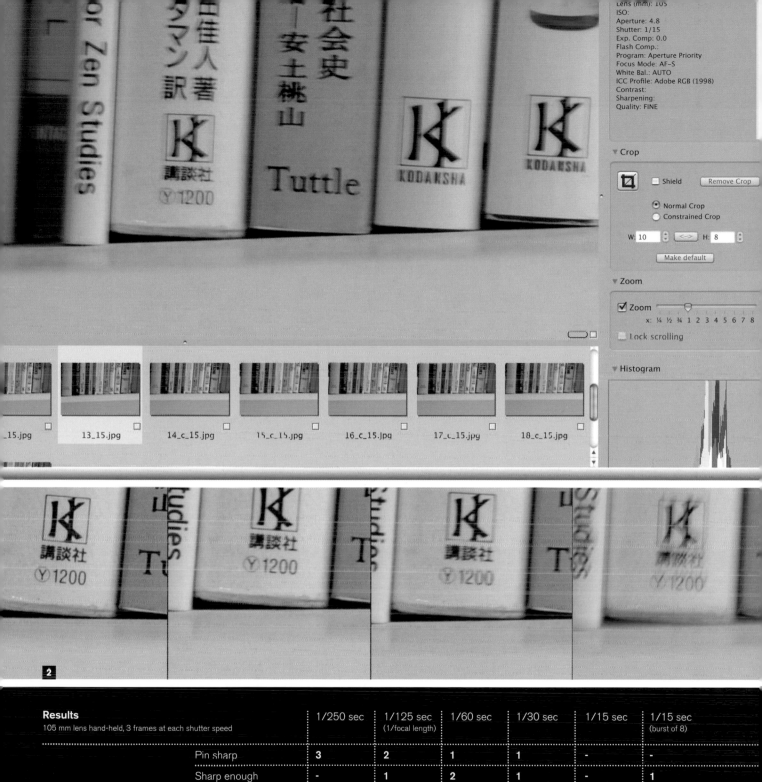

Lens (mm): 105
ISO:
Aperture: 4.8
Shutter: 1/15
Exp. Comp: 0.0
Flash Comp.:
Program: Aperture Priority
Focus Mode: AF–S
White Bal.: AUTO
ICC Profile: Adobe RGB (1998)
Contrast:
Sharpening:
Quality: FINE

▼ Crop

☐ Shield Remove Crop

◉ Normal Crop
○ Constrained Crop

W: 10 <-> H: 8

Make default

▼ Zoom

☑ Zoom
x: ¼ ½ ¾ 1 2 3 4 5 6 7 8

Lock scrolling

▼ Histogram

_15.jpg 13_15.jpg 14_c_15.jpg 15_c_15.jpg 16_c_15.jpg 17_c_15.jpg 18_c_15.jpg

Results
105 mm lens hand-held, 3 frames at each shutter speed

	1/250 sec	1/125 sec (1/focal length)	1/60 sec	1/30 sec	1/15 sec	1/15 sec (burst of 8)
Pin sharp	3	2	1	1	-	-
Sharp enough	-	1	2	1	-	1
Almost sharp	-	-	-	1	1	1
Significantly blurred	-	-	-	-	2	6

42

Improve your steadiness

Whether you found the last test sobering or encouraging, there is always room for improvement. Holding steady with a camera is like target shooting or archery, and some of the same techniques used by practitioners in these sports to improve their aim translate into photography as well. The following shows techniques for holding a camera in different configurations and for smooth shutter release.

Grip
The ergonomics of camera holding are a subject in themselves, and modern SLRs embody decades of manufacturing experience. How you hold the camera balances two needs—steadiness and access to the controls.

Stance
Your body is your camera support. Standing, the steadiest balance has the feet slightly apart, one a little in front of the other, turned out slightly at the ankle. In addition, keep the camera over your center of gravity, distribute weight evenly between both legs, and lean forward very slightly.

Bracing
Take advantage of any nearby support, as long as it's convenient and allows you

a good viewpoint. For example, use a wall as a brace, pressing hand, forearm, and head against it while pushing with your outer leg.

Adrenalin
A natural product of an exciting shooting situation. Tends to increase twitching and generally works against steadiness. It's difficult to do anything about it other than to think yourself calm—and follow the breathing advice...

Breathing
Slow, deep, and regular breathing steadies the whole system. Holding your breath may work for a few seconds, but you then pay the price by needing to take extra lungfuls of air.

Timing
Squeezing the shutter release as you near full exhalation is likely to be the steadiest time.

Moving onto the target
This is one marksman's technique. It makes use of inertia (mass x velocity) to overwhelm smaller jiggles and works well with long lenses. Move slowly down towards the framing you want, and shoot

without coming to a halt. This needs a good shutter speed. Squeeze, don't jerk. See Tip #44.

Ad hoc supports
Rest or press the camera against any stable surface nearby. The issue is whether or not this gives you poorer framing.

Image stabilization
Now built into a number of professional-level lenses. The principle is to link micromotors surrounding one or more ens elements to circuitry that responds instantly to the movements that cause camera shake. The micromotors react to move the lens element in the opposite direction. Not cheap, but gains two or three *f*-stops of speed.

43

How to hold
a camera

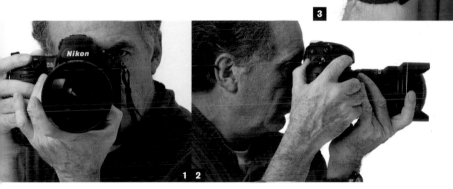

Don't take this badly. We all know how to hold a camera, but there is no absolutely standard grip, and everyone has his or her little variations. But they are all variations on common—and commonsense—principles. The examples here cover different lenses and the switch between horizontal and vertical. The fewer controls that you need to operate by hand, such as focus or zoom, the more of the grip you can devote to steadying the camera.

Basic
1-2 Elbows tucked in to chest, camera held firmly back to forehead. Wide firm grip around camera with right hand, all fingers supporting *except* for the forefinger, which stays flexible. Heel of right hand carries most of weight, under center of camera, wrist vertical. With autofocus on, only the rear zoom ring needs adjustment, and the thumb, second, and third fingers take care of this. The left forefinger helps support the front of the lens and the little finger pushes on the fingers of the right hand for extra support.

Extra strap support
3-4 A slightly steadier variation on the basic grip. Push outwards and downwards on the strap with the right wrist to tension it. This works only if you have the strap short.

Twisted strap support
5-7 Another variation. This works for slow speeds, but is a real mess to extricate your hand from afterwards. Twist the loose part of the strap around your wrist by rotating your hand as shown, until your hand is jammed up against the camera grip.

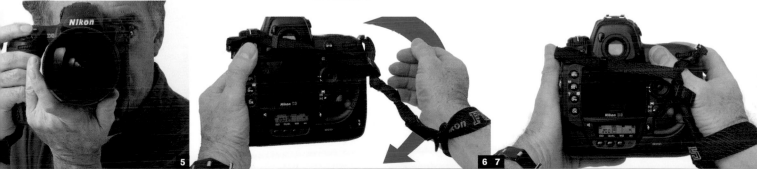

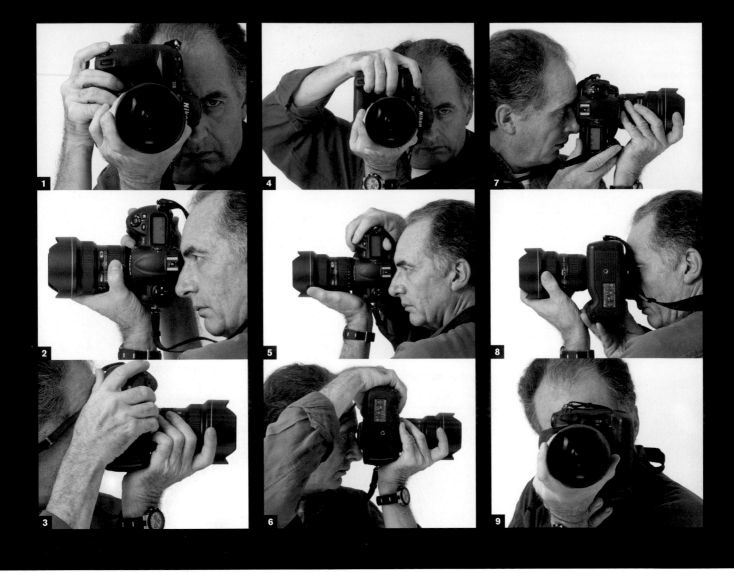

Vertical shooting with a secondary release

1-3 Some SLRs have a second shutter release on the corner for vertical shooting. It's not just a convenience, but allows a properly stable grip with elbows in, and both forearms vertical. All of the right hand except for the forefinger grips the side of the camera body with as wide a grip as possible. The heel of the left hand supports the bottom edge of the camera, while the forefinger and little finger add to the grip, with the thumb, second, and third fingers on the zoom ring.

Vertical shooting with standard release, overhand

4-6 Without a secondary shutter release, there are two options. This is the first, with the shutter release on top, calling for an overhand position. There's no alternative but for the right elbow to stick out, which does not add to stability. It places more of the job of supporting the camera on the left hand, with the heel of the hand taking the weight. The left eye stays clear and, as is normal, stays open.

Vertical shooting with standard release, underhand

7-9 The second vertical option with a single shutter release is with the release underneath. This keeps the elbows in, which is good, but tends to contort the right hand. One solution to this contortion is not to attempt to use the heel of the right hand, but instead use the fingers to press against the heel of the *left* hand, transferring some weight onto that. The right wrist stays on the chest.

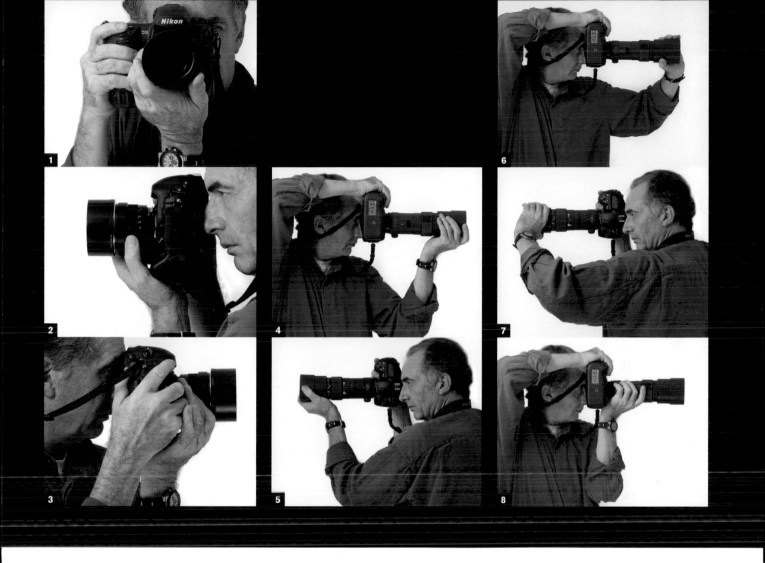

Manual focus

1-3 Non-autofocus lenses are quaint these days, but still available, and even with a regular lens you may prefer to focus by hand and eye. It means that your thumb and one or two fingers need to be free to work the focusing ring, so the heel of the left hand alone carries the weight. This is aided by an extra strong grip with the right hand.

Long lens, autofocus, front grip

4-5 Long lenses vary considerably in shape and size, and this largely determines how you can hold them. This is a fairly compact 300 mm lens with a modest maximum aperture, hence a small diameter front element. Long lenses prefer tripods, or at least monopods, but if you want to use one quickly, with greater flexibility, then hand-held is the only way. The right hand takes the usual firm wide grip, while autofocus frees up the left hand. If the lens hood is large, it's a good idea to spread the load by gripping it. Here the forearm takes the weight, although one problem is that the elbow is unsupported. Pulling the camera back firmly to the forehead is important.

Long lens, autofocus, overhand front grip

6-7 This is a variation on 4-5, and my preferred grip. Given that the elbow in the previous method is itself unsupported, you might as well take a firmer natural grip of the front of the lens, as here.

Long lens, mid-barrel grip

8 More conventional in that the left hand takes the weight in the middle of the barrel, with a vertical forearm tucked in as much as possible to the body. Somewhat awkward, but an alternative if you are using manual focus, or a zoom control.

44

How to squeeze the shutter release

Though there may only be a few things to say about this, the most basic action in all photography, they're important. The word "jab" does not enter into this vocabulary. Squeezing gently, but decisively, may sound like pathetically obvious advice, but for all kinds of reasons people who are not comfortable with their cameras tend not to. There may well be some subconscious component at work, on the lines of "right, it's all framed and focused and perfect, so let's just DO it," with a shove to the shutter release as if slamming a door. The same odd thing happens in the other kind of shooting, with rifles and handguns, where pulling on the trigger destroys all of the good work that's gone into getting everything steady on the sight. As long as you hold the camera approximately as on the last few pages, with at least the top two joints of the right forefinger free, there is no physical reason for jerking.

Nor does it take long to become accustomed to the resistance and feel of your camera's release (they do vary). Because a number of camera functions are activated by depressing the release halfway (such as autofocus), it's a good idea to practice the two-stage action—slight depression to activate, then continue in order to shoot.

With slow shutter speeds, there are one or two techniques that fall short of actually putting the camera on a tripod. As long as you can press the camera against something stable, you might consider using the self-timer to do the job for you—as long as the subject doesn't need a

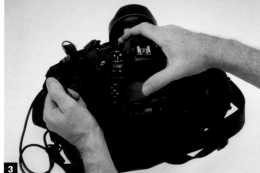

1 A slow, gentle movement in two stages. The first stage—halfway depression—activates functions. The follow-through, after a pause if necessary, triggers the release.

2 Using the self-timer allows internal triggering.

3 With a cable release, you can remove pressure from the camera body.

precisely timed shot. Or, use a cable release, which allows you to trigger the shutter without touching the camera body.

45

Carry a tripod

Obviously, this isn't a blanket recommendation, but something to think about if you are likely to face lighting conditions that will involve slow shutter speeds. However, packing a tripod can slow you down, be awkwardly bulky, and certainly identifies you to everyone around you as a photographer. In its favor, you can make exposures as long as you like, and keep the camera locked onto a view for which you might want to vary the settings (see Chapter 7, Multi-shot).

Everyone has their own preferences for style of tripod, but the light, strong materials like carbon fiber, which are unfortunately the most expensive, make carrying a tripod less of a chore. You also need a strap or light case, and a tripod head that locks tight but is easy to use. A quick-release system has a lot to recommend it. See the night shooting gear in Tip #95 for what I use.

... and tripods can stand or be wedged in all kinds of places.

46

When tripods are forbidden

There is a creeping culture of restriction when it comes to setting up and using a tripod, and it's happening in just those places where a tripod is pretty much essential to take a photograph—namely museums, galleries, interiors, and archeological sites. When faced with a situation where yes, you can take photographs but no, not on a tripod, there are a number of possible solutions:

* use a tripod until someone comes along and stops you
* use a monopod (but expect this to count as a tripod)
* use a mini-tripod and place it on some elevated surface or jam it against a wall. It's still a tripod, but you might get away with it as it won't alert attention at a distance

* use a mini-tripod on the ground, with either a shift lens (as shown here) or with the camera tilted up, later resorting to perspective correction in post-processing
* use a tripod head on its own, holding it down with one hand
* take a baseplate, perhaps even with a block of wood
* tip the caretaker or guard (depends on the country and the circumstances)

1-2 Use just the tripod head, as here in this Mexican site, where I had just been stopped using a tripod. The head was on a pile of stones.

3 A more evolved version of the tripod head alone—a baseplate, which is definitely not a tripod.

4-5 If you happen to have a shift lens for perspective correction, this can take care of ground-level shots.

6-7 Press a mini-tripod against a wall, which gives you more choice of elevation than horizontal surfaces.

8 Tilting the camera up from the ground can still work, if you correct perspective distortion later with software.

9 A monopod, not a tripod by the numbers, but you'll still probably get stopped.

47

Instant weatherproofing

Transparent plastic bags are an easy answer for protection against water, snow, and dust. The camera is inconvenient to use, but at least it's protected, and you can fix one of these in minutes. The bag should be large enough to allow some free play around the camera. As long as the lens has a clear view and there is some play around the controls, everything else can be sealed. Insert the camera, body first, into a strong plastic bag, and secure the bag's opening around the front of the lens with a strong rubber band. Use the LCD screen for viewing; it will be clearer than the viewfinder. An alternative is a large ziplock bag with the opening at the back of the camera and a hole cut for the lens this has the advantage that you can access the camera from the back easily.

1 Place the camera, lens up but without its hood, into a plastic bag.

2 Leave plenty of room underneath to work the controls, and gather the top around the front of the lens.

3 Slip a rubber band over the top to secure it.

4 Adjust the fit of the plastic bag.

5 Start to cut around, leaving a centimeter or so width.

6 Continue until all the surplus plastic has been cut away.

7 Fit the lens hood.

8 Work the controls through the plastic.

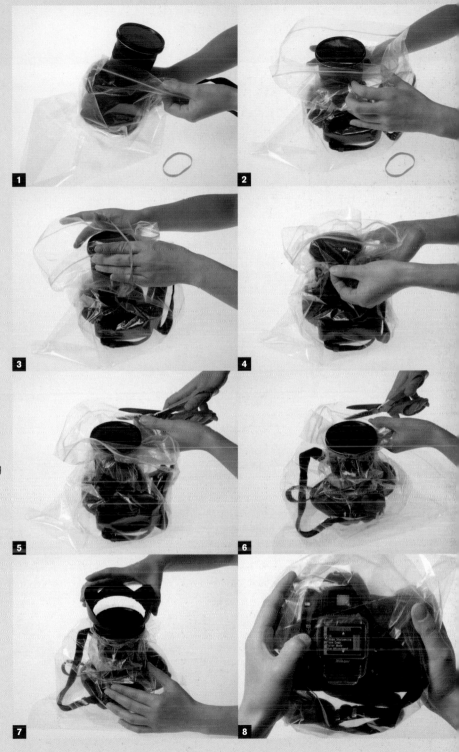

48

Cold weather handling

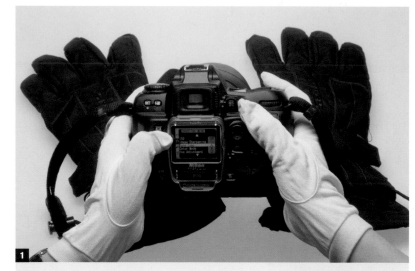

Sub-zero temperatures are less of a problem in themselves than what happens when the camera is moved between very cold and warm places. Condensation *will* form on cold equipment brought into a heated environment, and this can disable the electronics. One solution is to leave the equipment in a cooler part of the building or vehicle rather than bring it into the fully heated area. Another is to seal it in a heavy-duty plastic bag with as much air squeezed out as possible so that condensation forms on the outside of the bag, not on the camera. Even better is to add a desiccating agent such as silica gel.

Moving from warm to cold, the risk is that snow can melt on the body and in the joints, then re-freeze. This can even damage the equipment by expansion. Equally, condensed breath can freeze, so avoid breathing directly onto a warm camera. The solution is to allow time for the equipment *in its bag* to reach a similar low temperature before using it.

Batteries deliver less power at low temperatures and need to be replaced more frequently. Cell capacity is very low below −4°F, and a little lower than this the electrolyte will freeze (although when it thaws, it will start functioning again). Carry spares, and be prepared to re-charge often. Carry the spare batteries in a warm place, such as your trouser pocket.

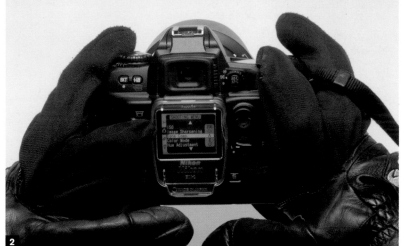

1 To avoid frostbite, and the painful risk of skin sticking to frozen metal parts, it's best to use silk inner gloves inside of regular winter gloves.

2 Some mitts have sewn-in inner gloves that you can expose by unzipping.

3 A metalized polyester "space blanket" gives good insulation for equipment, and wraps up small.

49

Heat and dust

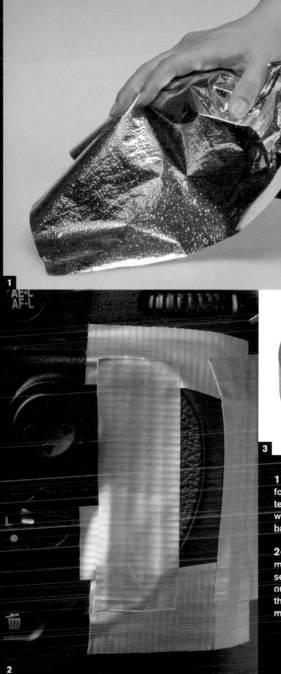

High temperatures are definitely more dan[...]o digital cameras than low temperatures, and few cameras are built for an operating environment of more than 104°F. Check the manufacturer's specifications for this. Most cameras and lenses being black, they absorb radiant heat quickly, and in conditions where shade temperatures are over 104°F, try never to expose to the direct rays of the sun. A "space blanket," or even a piece of reflective foil can make a simple impromptu shade—particularly useful if the camera has to be on a tripod in the sun for any length of time.

In hot and dry environments such as deserts, a more critical problem is likely to be dust and sand particles that work their way into exposed movements, particularly the lens focusing and zoom rings. If there is any wind, this is more than likely. Consider the weatherproofing technique using a plastic bag shown in Tip #47, and try not to c[...]enses on a digital SLR except in a closed environment (such as a vehicle).

1 A piece of reflective foil can cover the camera temporarily, or be secured with a couple of rubber bands.

2-3 Duct tape, among its many uses, is useful to seal any exposed joints on the camera body—in this instance the camera's memory card compartment.

Chapter_ 05

Composition

58 59 60 61 62 63 64 65 66 67

50

Compose for contrast

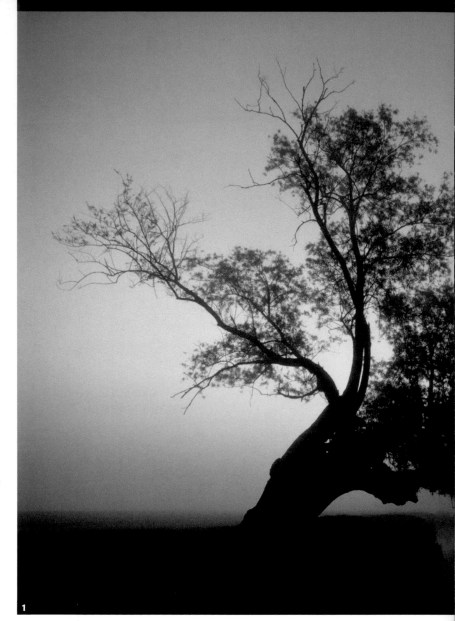

1

Composition deserves more attention than it usually gets in writing on photography, as how you organize an image is fundamental to the way it works. The decisions involved are many and complex, from choosing your viewpoint and camera angle to timing the shot so that the different elements come into the frame just so. There are no rules of composition in the sense that if you follow a formula the image will be a success, but there are principles and techniques that can be shown to have certain effects on most viewers. That is as far as anyone can sensibly go, and were you actually to follow any of these as rules, you would achieve thoroughly predictable, therefore boring, results. So, I should give advice with caution, and you should accept it cautiously. What we have in this chapter are pointers, ideas that have been proved to be useful before, and may help with a particular shot. No more than that.

The first principle, and a very broad one, is to consider contrast, in all senses. In one sense, imagery—and so photography—is all about contrast, be it contrast of tone, of subject, of placement, or of size. This principle was formalized at the Bauhaus in the 1920s by Johannes Itten teaching the famous Basic Course. Itten has had a powerful influence on modern design, and on this theory he wrote, "Finding and listing the various possibilities of contrast was always one of the most exciting subjects, because students realized that a completely new world was opening up to them." The method he taught was

first to experience contrast with the senses, then to consider it, and finally to create an image that embodied it. This works as well for composition in photography today as it did for his art students then.

1 This image is as much about the contrast between hard and soft as between light and dark, or between color and monochrome. Contrast can exist at a number of levels in any one image.

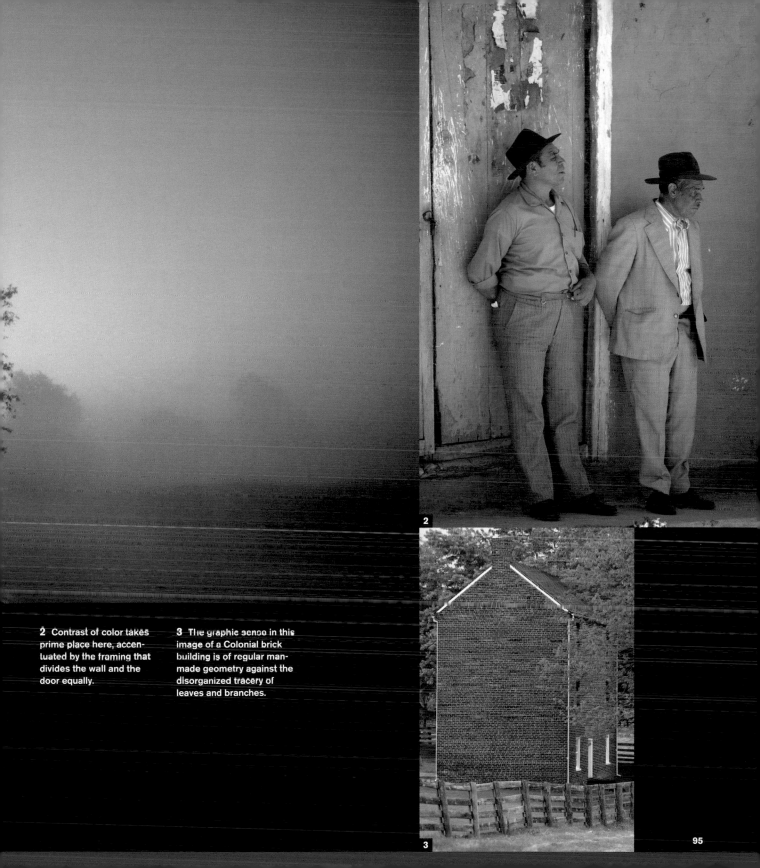

2 Contrast of color takes prime place here, accentuated by the framing that divides the wall and the door equally.

3 The graphic sense in this image of a Colonial brick building is of regular man-made geometry against the disorganized tracery of leaves and branches.

2

3

51

Dynamic placement

If you have a single subject that stands out from its setting, it obviously has to go somewhere in the frame. Exactly where it gets paced is important, partly because some positions are more interesting or "fit" better than others, and partly because the position may say something about the subject and what it is doing. For example, if the subject is a person walking, then the image will communicate something different if the figure is at one side walking *into* the frame, or at the other side walking *out*.

A single subject against a plain background is the absolute simplest situation, and the most primitive. Even though it is relatively uncommon in real life (I include an example here), it makes a useful test case. Bearing in mind that nearly all scenes are more complex, and that every additional element or complication adds layers of graphic relationships, this is a useful way of dealing with it, but it is *not* a prescription, because any formula quickly becomes boring.

Think of a single subject as having a graphic relationship with its background. This is even before considering *what* the subject is (a person, perhaps), and what it is doing (moving, for instance). Size matters, as always, but let's say the subject is neither tiny, nor is it almost filling the frame. The examples here show what I mean. To make it really simple, there is a range of placement from the center to the edge. Central suggests precision, rigidity, symmetry, and little interaction with the background. Maybe even uninteresting, but I hesitate to use that strong

a term. At the other end of the range, at the edge or in the corner, the effect tends to be extreme, highly asymmetrical, and certainly begging for a reason for it being so far out. There may well be a reason, but if not, it's more likely to seem perverse, being different for its own sake. But the subject very much interacts with its background, which dominates the image.

The in-between zone, whether left, right, up, or down, is generally more reasonable and useful, but involves many fine shades of relationship. As you move the subject off-center (shifting the view), it sets up a contrast with the larger, but more amorphous background working *across* the frame. This is when placement becomes dynamic rather than static. If you want a sense of balance, a position that approximates the Golden Section (see Tip #52) will do it. If you want more tension, a less resolved relationship, further out or even further in will help. As I said earlier, there are no prescriptions here, and no formula—just the dynamics to think about.

1 Placing the lighthouse quite eccentrically reinforces its relationship with the sea. The contrast of color, size, and between hard and soft is strong, and it helps explain the function of the lighthouse.

2 What I call a "boat-in-the-water" shot, where there is almost complete freedom to place the single object anywhere in the frame.

3 A man in a cathedral. Placing him here in the frame allows the figure to "face into" the shot—a conventional and usually successful approach.

53

Simplify

This is by no means a universal principle, as "simple" can also easily be boring, but it has a special place in photography. This is because the world in front of the camera is generally a messy place, and as composition is mainly about bringing some organization to this visual chaos, cleaning up the image frame works predictably much of the time.

It works because our minds respond to order and getting rid of clutter. Gestalt theory, enjoying a new surge of popularity because of its usefulness in modern communications such as interface designs, has a number of well-established "laws" of perception. One of them is the Law of Simplicity, which states that the mind likes visual explanations that are simple. Simple arrangements, simple shapes, simple lines, and so on. It probably goes a long way to explain the appeal of minimalism.

In composing a photograph, simplification relies heavily on choosing a camera viewpoint and focal length that crops out the unwanted bits. And, of course, on being able to see a simple arrangement in the mind's eye first.

1 Farmland does not normally bring to mind simplicity, but the stone barns and walls of this part of Yorkshire have a geometric purity. A long lens to crop in and framing to counterpoint the cubic buildings and diagonal wall make the most of this simplicity.

2 Minimal to the point of hardly looking like a home, this austere and striking entrance is decorated with a single sofa in the form of a pair of elongated red lips. Framing to include the upper doorway and balcony accentuates this, and establishes that this is a real interior.

54

The essence in detail

1 Masks of some kind, clearly, but they obviously call for an explanation. In fact, they are positioning masks for the laser treatment of cancer patients—and for the photographer a way of illustrating the procedures in an oblique fashion.

2 These are the hands of an old woman in East Flores, Indonesia. My driver and I had stopped on a long drive, and at first I was thinking of making a portrait, so we chatted. I then saw these amazingly textured hands. Set against her tie-dyed dress, with a stack of ivory bracelets for contrast, it was an irresistible shot.

1

2

Scale is one of the things that you can play with as a way of increasing visual variety, and of extending the coverage of a subject. At the small end of the scale, sometimes you can find that less is more, meaning that a detail can encapsulate what is essential in the larger subject, and often present it more forcefully. The thing about details is that they are often overlooked, and as the photographer's job is usually to direct the viewer's attention towards something or a way of seeing something that they had not thought of, details can be very successful in photography. This is the world of close observation, catching parts of subjects that many others would not have thought of or paid attention to.

55

Shapes organize

How strongly shapes appear in an image depends on how they contrast (mainly tone or color) with their settings. Of course, subjects have a shape, but the shapes that have the most graphic interest in an image are those that occur a little less obviously. Subtly formed shapes that are implied and understated are some of the most useful of all; they help to order an image into a recognizable form and allow the eye the satisfaction of discovering them by making a little visual effort. Although it might seem that there is infinity of shapes, there are only three basic ones: the rectangle, triangle, and circle. All others, from trapezoids to ellipses, are variations on these. Each is intimately connected, both graphically and expressively, with the kinds of line that enclose them. Rectangles are the product of horizontal and vertical lines; triangles are built from diagonals; and circles from curves. While the principal design value of lines is to direct the eye, shapes organize the elements of an image. They can enclose, they can separate subjects into groups, or they can exclude. And organization is at the heart of composition.

1 The curves of seating partitions, together with the strong color, do an effective job of dividing the frame and enclosing the partial figure of the man.

2 The key frame of quite a long series of images of the preparations for a parade in Vietnam. At just this moment, the girls had their hats held in unison to shade their faces from the midday sun, while the wind caught the hem of one dress to create an unusually precise combination of a triangle and two circles.

56

Basic triangles

1 With a lot of people in the shot (and this grouping, in a Brazilian *favela*, just kept growing as more children wanted to be included), a rough triangle like this, created by having some sitting on the floor in the foreground, others sitting on chairs, and others standing, was an easy solution.

2 I had already taken several shots of this bathing scene in India. For one microsecond it all came together in a structured triangle. Unpredictable, but I saw what was happening and caught the moment quickly.

1 2

The triangle is the simplest and most common graphic shape. It needs only three points reasonably separated, or three edges that converge on each other. Shapes organize, as we saw on the previous page, and the triangle organizes the most easily. For example, if there are three faces in the frame, they will usually be focal points of attention. They almost naturally tend to read as the points of a triangle. In a still-life composition with several objects, this is one of the most straightforward ways of arranging them,

although it is often better to avoid complete precision. Inverted triangles work just as well.

Accentuating the triangular structure in an image is mainly a matter of framing so as to remove from view other distracting points and lines. This could involve altering the viewpoint (for instance, lowering the camera might hide some ground-level details from sight, while moving or zooming in can lighten the composition), or in the case of a studio shot you could rearrange the objects.

57

Diagonals move

Diagonals introduce dynamism into an image. They activate the frame, and also, valuably, suggest movement along them.

In the camera, most diagonals are created by viewpoint and perspective. The horizontals and verticals of buildings, streets, and other manmade things converge when shot from an angle. The stronger the angle and the shorter the focal length, the more convergence and so the more powerful the diagonal movement. In architectural shooting, photographers usually go to lengths to *correct* this entirely natural effect of lens optics, because our eyes tend to compensate for it when we look in real life, but for a more dynamic composition, stay with the diagonals. They can even be exaggerated, by widening the zoom, and by tilting the camera.

1

1 This Japanese courtyard could have been photographed square on, but a wide-angle lens from one corner gave a more dynamic composition, heightened by the last-minute appearance of a sliver of sunlight that adds another diagonal to the scene.

2 Angling the camera off the horizontal makes even more use of the graphic effect of diagonals, as in this close portrait of an animation artist at work.

3 Oblique views of right angles produce zigzags; a chevron effect of multiple diagonals. The angles are jointed, so the impression of movement along the diagonal is maintained, but with a sharp kink. It always helps to offset distinct lines like these with other elements—in this case, two figures conveniently at each apex.

4 With its wide angle of view, a short focal length almost automatically creates converging diagonals when the viewpoint is close and strongly angled.

58

Curves flow

1
2

Curved lines have much of the same potential for movement, direction, and a general sense of action as diagonals. They are softer, however, with a sense of flowing. They are also rather more difficult to find in scenes, because they cannot simply be created in the same way as diagonals by using a wide-angle lens and a strongly angled view. Being rarer, they are that much more interesting, and as with all the other basic graphic elements—points, lines, and shapes—they work best in a photograph when they are not obviously manufactured. You don't get points for just photographing a curve that someone else, such as an architect or graphic designer, has already produced. This example shows what I mean—not insistent, in no way very obvious, but it adds structure and interest to an otherwise potentially ordinary shot.

1-2 I needed a position for a portrait of this Shanghai artist, Liu Jian Hua, in his messy warehouse workshop. The least cluttered place was up on this balcony, which already had one of his works lying on the floor; a distorted sculpture. This series of sculptures features curved distortions, so why not build that into the shot? I positioned him behind and asked him to look over the balcony, which put a curve into his stance. At one point he looked in the other direction, and quite unexpectedly this made the curve more interesting.

59

Vertical virtues

Most photographs are taken in a horizontal format, mainly because that's the way most cameras are designed (you might argue that manufacturers make them that way because most people like to shoot horizontally, but the net result is the same). Shooting in a vertical format means turning the camera on its side, and there's a natural resistance to this, yet logically it gives you much more scope and variety in composition. Professional photographers usually make an effort to shoot vertically as well as horizontally because of the demands of their clients; most printed pages are vertical. If you don't do so already, try to trigger the choice—would this be better vertical or horizontal? It soon becomes so natural to consider this that you hardly notice the decision.

Vertical subjects, or vertically organized groups of things, are the most obvious reason for shooting this way, but there are more interesting reasons. One is to force the viewer's eye—and attention—up or down a scene, and as the canal shot here illustrates, this has a special relevance for telephoto lenses used in landscapes and other scenes that have depth. There are more subtle reasons that include playing with the contrasting relationship between graphic elements. The eye scans more naturally from side to side, so there is a little more perceptual effort in dealing with the top and bottom of a vertical image, as shown here.

1 The most obvious use of a vertical framing is when it simply fits the subject, as with full or three-quarter length human figures. Here, we see a Burmese dancer at a local festival.

2 A 2:3 vertical frame exercises the viewer's eye more than a horizontal, and that can make it interesting to work with in making a composition. In this late afternoon view of an adobe wall in New Mexico, placing the top—with its shaped sliver of blue sky—right at the top, makes more of the contrast than it would have done in a horizontal view.

3 Vertical shooting has a special use with long focal length lenses, particularly with landscapes and cityscapes. With the right kind of scene, a vertical frame makes the most of depth within the scene. This shot of a canal winding through fields makes the case strongly, channeling the viewer's eye up and down the image.

60

Look for rhythm

Rhythm in an image is the visual equivalent of the beat in music. It involves pattern and repetition, but more than that, it has a sense of direction and cycle. In images like the two examples here, the eye finds a kind of satisfaction in being carried through the scene in a rhythmical way. As in the other uses of lines and shapes, this doesn't have to be overstated, and is usually a result of the photographer spotting the possibility rather than planning it in advance.

1 Ranks of Thai soldiers in exuberantly designed ceremonial uniform make the kind of repetitive pattern that always establishes a strong sense of rhythm. To make the most of this, a very long lens (600 mm) was used from an angle. Framing to make sure the rhythmic pattern continues past the left and right frame edges was also important.

2 Another form of repetition, the design enlivened by the girl wiping down these Thai paper umbrellas drying in a workshop yard. As with the shot of the soldiers, the key to success is filling the frame with the pattern, so the eye thinks that it might be endless.

61

Try motion blur

In low-light photography in particular, a lot of effort goes into avoiding motion blur—the streaking and smearing caused by either the camera moving or the subject moving. After all, the default quality for photography in general is sharp images. Nevertheless, motion blur can be a desirable quality, depending on taste and on whether you can get it to work in a dependable way. Of course, if you have a nighttime shot in which lights move against the dark background, that quickly becomes very predictable. But darker things moving against light and complicated subject movement can produce unexpected results, even if you do this a lot. And deliberately blurred movement is a technique best use sparingly.

There are many precedents among the old masters of photography, including Ernst Haas's series in the 1950s on rodeos, bullfighting, and racing. Not everyone likes this kind of image, but if you do, and I do occasionally, it tends to work because of the way in which colors and tones are washed and swirled together. It all has to do with relative movement in the frame, and so the effects vary with the exposure time, whether and how you move the camera, the focal length of the lens, and how the subject moves. In addition, the arrangement of colors and tones in the scene to begin with is of major importance. The best approach is to experiment, which with digital photography and immediate playback is very easy.

1 I panned from right to left to follow the movement of the two figures walking. With a long focal length lens (400 mm) and a 1/2 sec exposure there is motion smear over almost everything, but some details are almost sharp, the end result being a scene that is just about readable.

2 Walking forward while shooting with a wide-angle lens (efl 27 mm) and a 1/3 sec shutter speed creates a kind of tunneling effect.

3 A medium long focal length (efl 135 mm) and a slight pan at 1/20 sec. Slight motion blur adds a sense of movement, without detracting significantly from the detail of these two women shopping in a Yunnanese market.

62

Alignments

As we've seen, whenever lines and shapes put in a distinct appearance they give some structure to an image. In the same way, when subjects in the frame appear to line up or share some kind of graphic connection, this too gives cohesion.

Actually, there are many pitfalls here, not least the suggestion that a photograph *should* have this kind of alignment. To do this regularly would become a mannerism, but on occasion, when it becomes possible or you see the potential, it may be worth exploring. Like any obvious technique, it can just as easily come across as a trick instead of a nice compositional move. Here are two examples, not dissimilar in that they juxtapose a figure with some feature from its background. Obviously, there are many other possibilities that would occur to different photographers; there is a strong element of personal taste involved. You may not even like the idea at all, as it treads a fine line between neatness and contrivance.

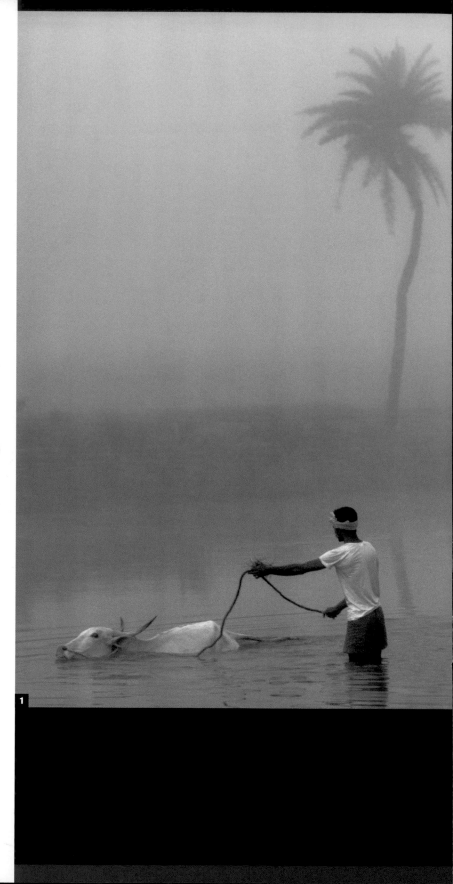

1

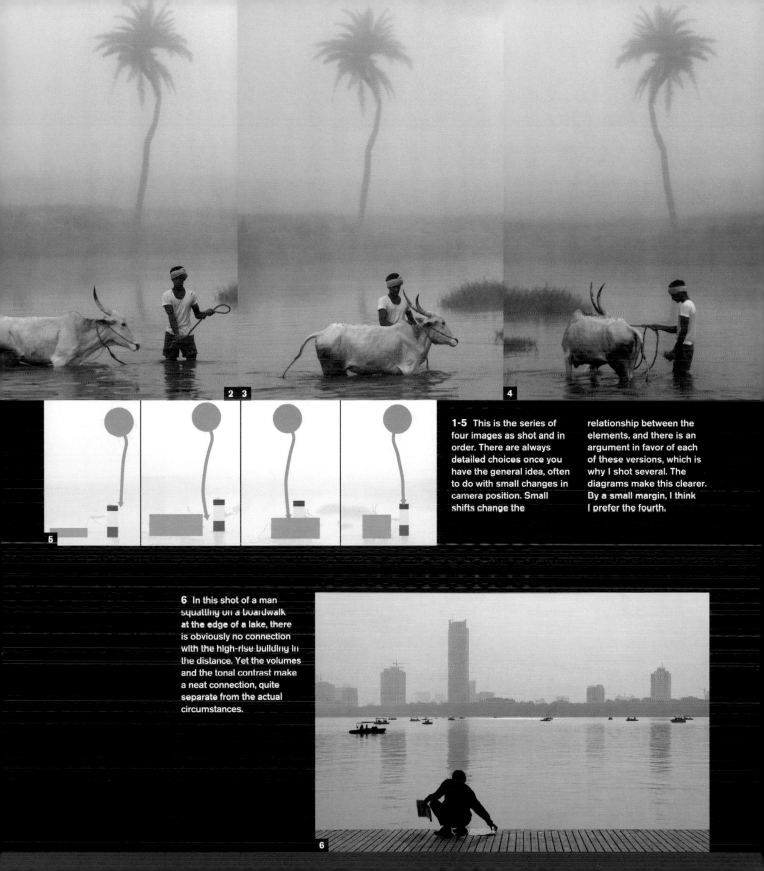

1-5 This is the series of four images as shot and in order. There are always detailed choices once you have the general idea, often to do with small changes in camera position. Small shifts change the relationship between the elements, and there is an argument in favor of each of these versions, which is why I shot several. The diagrams make this clearer. By a small margin, I think I prefer the fourth.

6 In this shot of a man squatting on a boardwalk at the edge of a lake, there is obviously no connection with the high-rise building in the distance. Yet the volumes and the tonal contrast make a neat connection, quite separate from the actual circumstances.

63

Juxtaposition

Juxtaposition is one of the major tools in
photographic composition. We like the idea of
relationships between things, and as photography
is the medium *par excellence* for bringing instant
order to the visual chaos of daily life, it does a great
job of suggesting a relationship by bringing subjects
together in the same image. It's a simple enough
graphic device, but it works.

Selecting viewpoint is the main action, but what
counts is seeing the potential connection between
different elements. This is more art than technique,
and really not amenable to a few cheap formulae.
But in terms of composition, it obviously helps to
simplify the scene and to crop out extraneous
elements that would distract from the main purpose.
Other suggestions in this chapter, including
Compose for Contrast, Dynamic Division, and
Simplify, may help.

Juxtaposing with a wide-angle lens differs in
technique from using a telephoto lens, but both can
be very effective. A wide-angle treatment can be
useful when you have a smaller foreground subject
and you want to exaggerate its size relative to a
larger subject beyond. Small changes in your
camera position have major effects on the
composition, and good depth of field usually makes
it easy to keep most of the image sharp (but stop
down as much as possible).

With a telephoto lens you need to change the
camera position more in order to see the
relationship change between subjects, but moving
makes fewer major changes to the rest of the image
than it would with a shorter lens. The compression
effect of a long lens is extremely valuable in bringing
together two subjects that are a distance apart, and
also compresses their relative sizes.

1

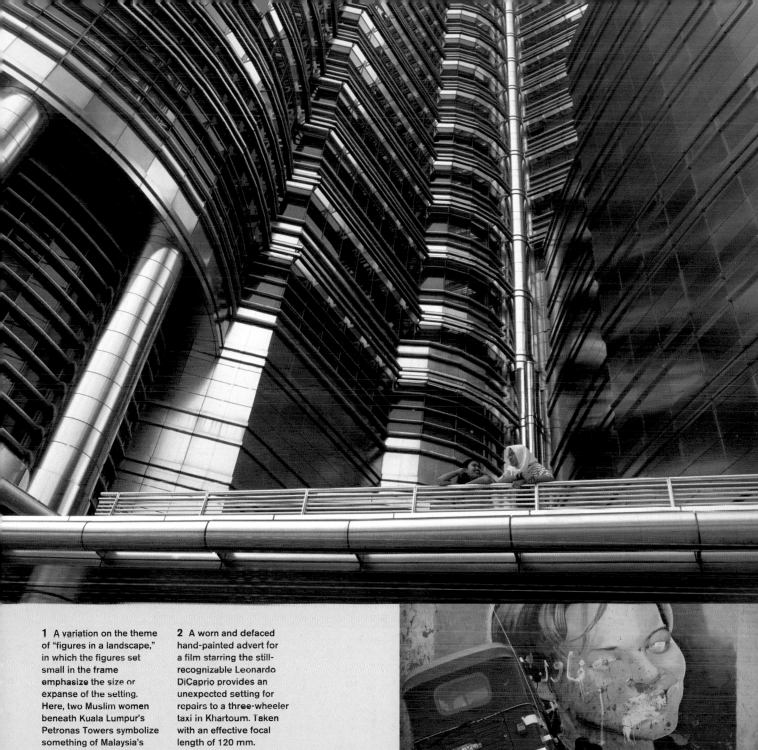

1 A variation on the theme of "figures in a landscape," in which the figures set small in the frame emphasize the size or expanse of the setting. Here, two Muslim women beneath Kuala Lumpur's Petronas Towers symbolize something of Malaysia's contrasts between tradition and development. Taken with a 20 mm lens.

2 A worn and defaced hand-painted advert for a film starring the still-recognizable Leonardo DiCaprio provides an unexpected setting for repairs to a three-wheeler taxi in Khartoum. Taken with an effective focal length of 120 mm.

2

64

Wide-angle involvement

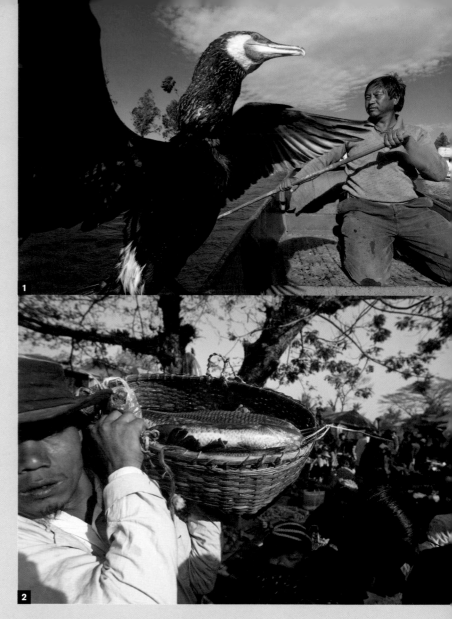

Choosing focal length is one of those things that is influenced not only by the subject and situation, but also by personal preference in your way of working. To take the practical conditions first, there is a clear contrast between, say, a sports photographer on a football touchline, and a street photographer in a fluid, uncertain scene. You may have no choice in the focal length, or it may be completely open.

But when you do have that choice, focal length style tends to fall into two camps: wide-angle and telephoto, with the lengths surrounding standard as a possible third style for those photographers who either prefer the "purity" of normal optics, or who don't care for extremes. Even within the labels "wide-angle" and "telephoto" there are sub-groups, from extreme to moderate.

There are several ways of thinking about wide-angle optics, from the purely practical coverage that they give, to the less definite, but very important impression they leave on the image. In particular, a wide-angle lens is the choice for subjective involvement—drawing the viewer in to experience the here-and-now of the situation. Use it close in a crowd and you project the viewer right into the middle of the scene.

1 A wide-angle (efl 18 mm) shot of a cormorant fisherman with one of his charges reverses the size relationship and works mainly because you would not expect to be able to get this close to the bird. Strong late afternoon sunlight helps give definition, with a good depth of field from an aperture of ƒ11.

2 Walking through a Burmese market with the camera at eye level and a 20 mm lens gives a highly subjective impression, heightened by passing the man carrying fish with just a few inches distance.

Telephoto detachment

A longer focal length pushes you back—if you keep the same framing, that is. And if the picture situation gives you the choice of where to stand, from up-close with a wide-angle lens to back across the street with a telephoto, this distance communicates itself in the atmosphere of the shot. By now almost everyone is familiar, as viewers of television and readers of magazines, with the different appearance of wide-angle, normal, and telephoto, even if they don't think about it technically and just register it subliminally. As a result, distance and involvement communicate themselves subtly through the choice of focal length.

When you use a long focal length, you are actually showing that you are standing back and are not completely part of the event. In addition to their practical uses, long focal lengths are essentially cool and detached, so "distant" in more than one sense. This detachment is at its most obvious in reportage shots, and there can almost be an impression of eavesdropping. With very long lenses—500 mm plus on an SLR—there can even be the sense of seeing more than you expect, which comes across particularly well in good wildlife photography.

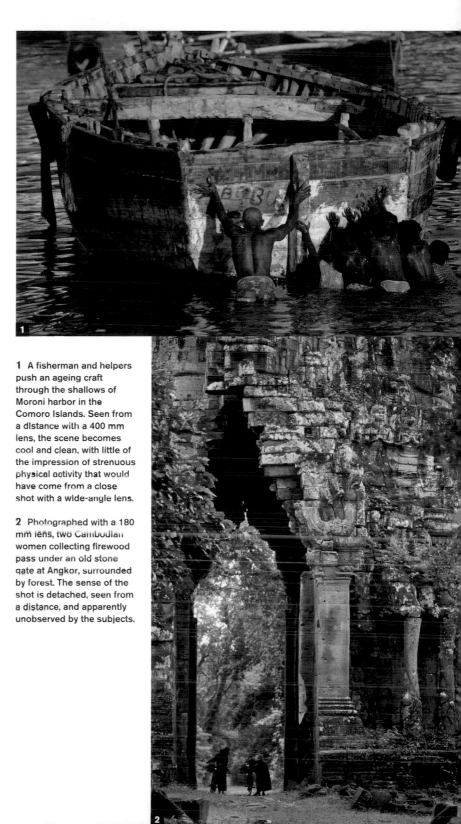

1 A fisherman and helpers push an ageing craft through the shallows of Moroni harbor in the Comoro Islands. Seen from a distance with a 400 mm lens, the scene becomes cool and clean, with little of the impression of strenuous physical activity that would have come from a close shot with a wide-angle lens.

2 Photographed with a 180 mm lens, two Cambodian women collecting firewood pass under an old stone gate at Angkor, surrounded by forest. The sense of the shot is detached, seen from a distance, and apparently unobserved by the subjects.

66

Wide-angle for dynamics

1 In addition to doing a practical job of showing all the essential elements in this lunchtime scene in a traditional Tokyo restaurant, a wide-angle lens (efl 18 mm) gives a strong structure of converging diagonals and a certain amount of visual punch.

2 A group of Japanese girls dressed as their favorite baseball players. Another use of an efl 18 mm focal length for a striking dynamic structure, the arrangement of the figures matches the linear distortion of the lens, which becomes less noticeable as a result.

1 2

We have looked at the subjective impression that a wide-angle lens gives to a scene, but an equally important quality is its optical effect on the graphic structure of an image. Wide-angle distortion is a result of compressing a wide angle of view into an image that is viewed at a much narrower angle—on a page, a print on a wall, or on a computer screen. In other words, it boils down to the viewing distance between the scene and the image. This distortion disappears if you stand very close to a large print.

The greater the difference between the wrap-around coverage from the wide-angle lens and the size of the image, the more the distortion. Lenses with an efl of 20 mm or shorter create very strong distortion, and the stretching effect increases outwards from the center, which can create a powerful sense of dynamics. Use the viewpoint effectively and you can use these diagonals to focus attention (they often tend to converge inwards) and generally enliven the image.

Telephoto to fill the frame

In contrast to a wide-angle lens, a long focal length *suppresses* angular distortion to give a characteristic "flattening" effect. This certainly plays a part in the character of the image, but the quality I want to promote here is a more practical compositional one—the useful way in which a long-focus lens helps you to escape horizons, skies, and an overall similarity of viewpoint. The same subject photographed with different focal lengths has very different relationships with its setting, and particularly the background. The effect is that you can often extract more visual variety from a single situation than would be possible with a wide-angle lens.

1 The colors in this Tuscan landscape are clearly important in the way this image works, particularly the glossy browns and blacks, but the success of the composition relies heavily on the ability of a 400 mm telephoto lens to close in on the trees and make them appear as a uniform background.

2-3 The souk in Jeddah, Saudi Arabia, is one of the few parts of the old city still preserved. The standard-to-wide-angle view (efl 45 mm) suffers the usual tyranny of a skyline that does nothing for the image, but a moderate telephoto view (efl 160 mm) from an elevated viewpoint at a distance allows full concentration on the old buildings, presenting them in an organized way, while losing the sky.

Chapter_ 06

 68
 69
 70
 71
 72

Stitching

68

Stitching—Digital's specialty

1-2 From a fairly wide selection of frames, shot in several rotating sequences, 8 were chosen for stitching to create this panoramic view of Chinese artist Shao Fan's studio.

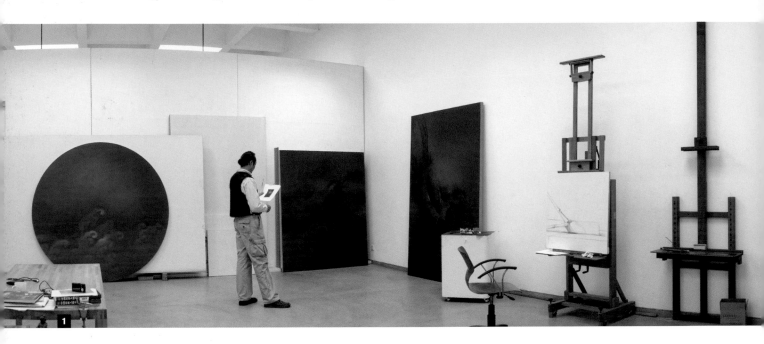

I'm naturally suspicious of technology that purports to inspire creativity. Too often it's just playing around with gimmicks, but for stitching I make an exception. The technology, which has evolved over the last few years, is impressive, but the concept is dead simple—stitching is a way of combining overlapping images seamlessly into a larger view.

This was close to impossible in pre-digital days, but digital stitching software has made it far simpler. The creative freedom it unlocks is twofold: the opportunity to make panoramas up to 360°, and to make very large, high-resolution images. Large is not simply a technical point; it allows a different viewer experience of photographic prints, and significantly it has had an impact on fine art photography. A number of art photographers rely on this technology to create huge, detailed prints.

69

Stitch big

Stitching overlapping frames has one obvious effect of increasing the size of the final image, which means there is no limit to resolution. Put it this way: instead of shooting at 50 mm, try racking the zoom to 100 mm and photographing the same view in overlapping sections. The result will be a file size four times as large, as if you had shot with a sensor with that much more resolution. In the days of film, when you needed a high-resolution image you would have reached for a view camera and shot, say, 4x5-inch film. If you need high resolution now, the sensible choice is to buy a digital back for a medium- or large-format camera, but the cost is high. If you are prepared to put up with some inconveniences, stitching is a no-cost way of jumping to big, high-resolution images. Take any scene (well, it has to be fairly static, admittedly), and divide it into segments. The longer the focal length of lens, the more segments. A wide view shot with a long telephoto can be huge; just do the math.

A 15 mm lens on a full-frame digital SLR covers a diagonal angle of view of 110°, which really is "wide angle." Now imagine shooting the same angle of view with a 120 mm lens, a bit at a time. The 120 mm lens's 20° view divides into 64 segments, and with the overlap needed for stitching that would take the number of frames up to around 100. If you're using a 10-megapixel camera you would

end up with an image measuring some 31,000 x 21,000 pixels once those 100 frames have been stitched together. That's like shooting with a 640-megapixel camera!

There are, of course, several drawbacks. First, it takes time and it's rather fiddly. Then, if anything moves in the scene while you shoot, some frames will be mismatched. Good software can handle much of this, but the processing of all those images takes time, computer memory, and speed. The example above—which would output 2 GB of data—clearly calls for an incredibly powerful computer.

But despite all this, stitching is on call at any time, and needs almost nothing extra at the time of shooting. The "almost" refers to camera mounts for tripod heads that make it possible to rotate the camera around the nodal point of the lens, which is useful if you have a close foreground in shot, as it takes care of the problem of parallax.

1 A single shot of Pudong skyscrapers, including the Shanghai World Financial Center, with an efl 80 mm lens on a 12-megapixel camera, measuring 4,100 x 2,800 pixels.

2-10 Shooting nine overlapping frames with the same camera and an efl of 200 mm (more than twice that of the single shot) produces a stitched image that measures 15,300 x 4,000 pixels— the equivalent of 61-megapixels.

70

Stitch wide

1 Asia's largest LCD screen, installed as a ceiling the length of a city block over a Beijing shopping mall. Its size and overhead position called for a strongly angled view that in a stitched panorama creates an upward-curving distortion—here a striking complement to the surrealistic scene.

Panoramic images are still the major use of stitching, and they can be exciting and impressive for a number of reasons. These are images that are significantly longer than they are tall, and while there is no exact limit at which a photograph suddenly classifies as a panorama, proportions of 3:1 or wider certainly fit the bill. Why are panoramas so popular? Why indeed are widescreen formats popular for television and film? Probably because we tend to look at large scenes like landscapes in this way, scanning horizontally, and because they give the eye time to explore. Panoramas give an expansive, sweeping sense to a view. And of course, there is no limit as to how wide they can be—you can just

keep adding frames as you rotate the camera, even up to a full 360°.

The frame dynamics of a panorama are different from what we're used to, and to make the most of the composition there are a number of things you can do, as you can see from studying the way cinematographers handle the framing (i.e. in widescreen). One is to separate subjects of interest horizontally, "pulling" the composition apart from left to right. Unlike a normal 3:2 ratio SLR frame, a panorama can handle two, or even three subjects in the same composition. Another method is to include strong foreground interest to balance the background and move the eye around the frame.

2 Also in China, a circular Hakka clan house known as a *tulou*, in Fujian province. The wide expanse and cramped viewpoint make another compelling case for a stitched panorama. Using an efl 18 mm lens in vertical format, this stitch covered 5 frames horizontally, with a second sequence to increase the depth.

 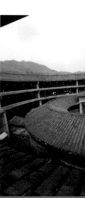

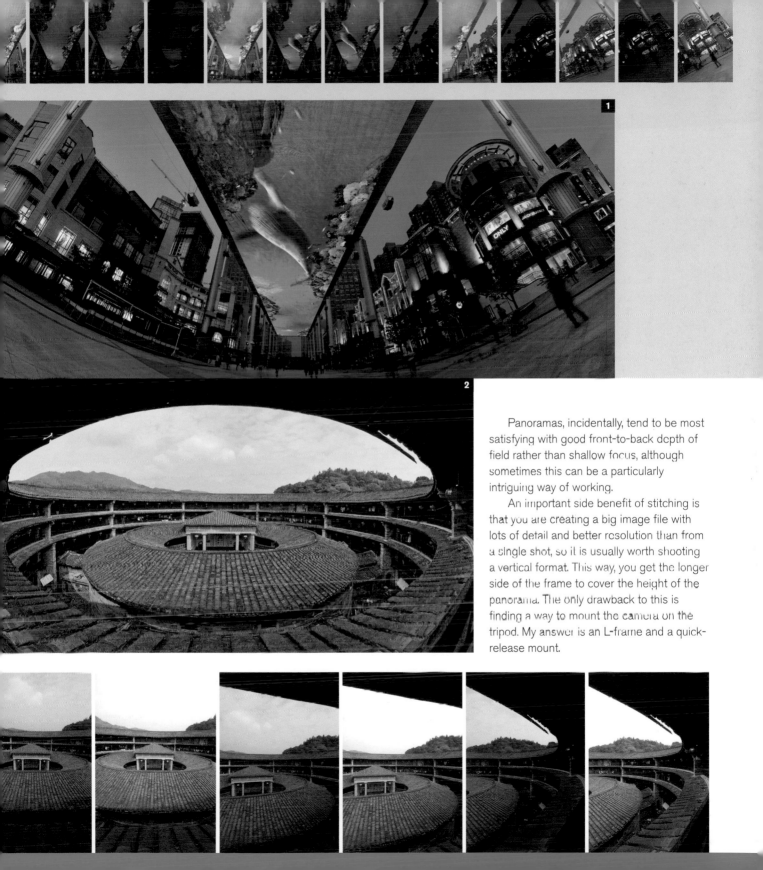

Panoramas, incidentally, tend to be most satisfying with good front-to-back depth of field rather than shallow focus, although sometimes this can be a particularly intriguing way of working.

An important side benefit of stitching is that you are creating a big image file with lots of detail and better resolution than from a single shot, so it is usually worth shooting a vertical format. This way, you get the longer side of the frame to cover the height of the panorama. The only drawback to this is finding a way to mount the camera on the tripod. My answer is an L-frame and a quick-release mount.

71

Efficient overlaps

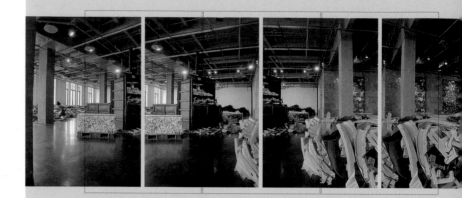

For this view of an art installation in a gallery, four frames were overlapped by approximately 40%. There is ample detail in the scene for the stitching software to recognize content.

There are three stages in stitching. First, the software has to find corresponding areas of content in adjoining images and warp them so that they are in perfect register. Second, it has to blend the tones so that they match smoothly. Last, it combines the multiple images as one.

The first step relies on there being enough of an overlap between neighboring frames for the content to be recognized. That means enough corresponding points in each image. Ideally, you want enough of an overlap for this without overdoing it and shooting more frames than necessary. There is no hard and fast rule on this, partly because different software varies in its ability to do the matching automatically, but more because the quality of the detail depends on the scene itself. Sharp detail is best, and stitchers understandably have difficulty with featureless areas like sky and white walls. Around a 40% overlap is fairly safe, but you might want to vary this according to how detailed the scene is. Personally, I like to keep things simple and consistent by overlapping just under half. In practice, this means rotating between frames in such a way that an object on the edge of the frame in one shot is almost in the middle of the next, and so on. As I always do this the same way, I can shoot a panorama quickly and without having to think very much, and that's not bad.

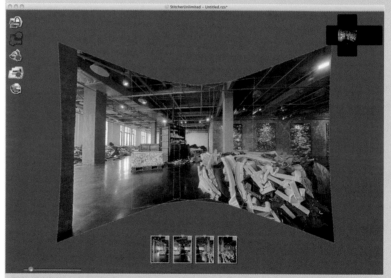

72

Keep the settings consistent

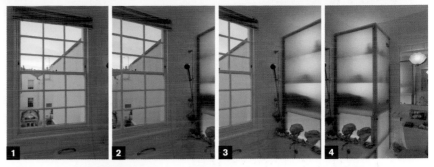

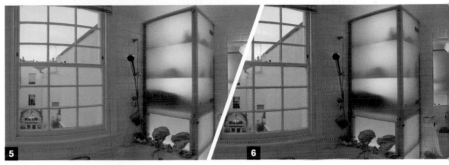

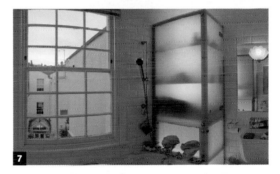

The second stage in the stitching procedure, as I described on the previous pages, is the blending, and this involves color as well as tone. If you keep the white balance the same for all the frames, this will make life easier for the stitching software. And this applies to other settings as well, including exposure. For this reason, the standard advice when shooting a sequence for stitching is to switch to manual and keep the settings consistent. This might well involve doing a dry run and checking what the settings should be for each frame in the sequence.

As 360° panoramas are quite likely to include light sources in shot (especially outdoors on a sunny day), this can mean that a single exposure and color setting might cause out-of-range values in shadows and/or highlights. In other words, it exceeds the dynamic range of the camera (see Tip #15), and this is quite common. The usual solution in this case is to take a sequence of exposures for each frame, and then combine the results either through exposure blending or HDR.

That said, if you shoot Raw it doesn't matter very much, other than the extra time making color adjustments in the Raw converter. An interesting and useful technique is to change the color balance progressively. Imagine a scene in which the color temperature varies, such as from daylight on the window side of a room, to tungsten on the other. In post-production you might well consider trying to normalize the balance, but if you were to select Auto white balance when you shoot a stitched sequence, the software will make an attempt at doing the blending automatically.

1-8 An example of going against the standard advice for consistent white-balance settings. The four source frames were shot in Raw, but also with Auto WB, and so the color temperature changed from left to right [1 = 5500K, 2 = 4500K, 3 = 4000K, 4 = 3300K]. The result, once the stitching software had blended them, is a progressive change which, to my mind, gives a better balance between the blueish exterior and yellowish interior. Final retouching using Replace Color took care of the reddish tinge on the right side of the window frame. For comparison, here is a stitch using a consistent, tungsten WB.

73

Finding the nodal point

The software that stitches two adjacent frames together performs a clever operation that involves distorting each to fit the other, but for this to work the relative positions of everything in each frame needs to be the same. The biggest obstacle to this is parallax, caused by slight shifts of the camera position. Certainly the camera has to move, but that means rotate only. If there is any offset, particularly with the wide-angle lenses normally used in stitched images, the result is likely to be that some foreground objects will appear ghosted. The key to this is to make sure that the camera rotates exactly around what is called the nodal point of the lens. You can think of this as its optical center (although because of the many varieties of lens design with different elements, this is not necessarily the physical center of the lens). With a zoom, this varies with the focal length.

There is one simple way of finding this for any lens, using a little trial and error. Panoramic heads built for stitched images are adjustable in the sense that the camera can be locked at different positions. When the nodal point of the lens is exactly over the point of rotation of the head, there will be no parallax problems. To find this, position the camera on the panoramic head and on a tripod so that through the viewfinder you can see two vertical edges, one in the

1

extreme foreground and one in the distance, close together. Looking through the viewfinder, rotate the camera while watching the slight gap between these two edges. If it widens or narrows as you swing the camera around, move the camera on its mount slightly, either forward or backward, until it stays the same, as the example here shows.

1-3 This pair of images (1 and 2), was shot with a 14 mm focal length, purely to establish the nodal point. With the left-hand frame as reference (3), notice the parallax shift between the wedge of window frame and the window opposite. The camera was repositioned by trial and error until no parallax shift was apparent.

4 The nodal point of the camera is directly over the center of rotation of the panoramic head.

Chapter_

07

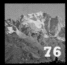

Multi-shot

79 80 81 82 83 84

74

Bracketing— the safety net

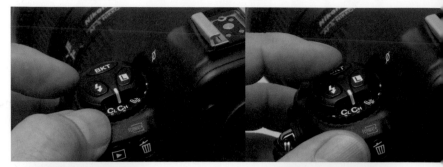

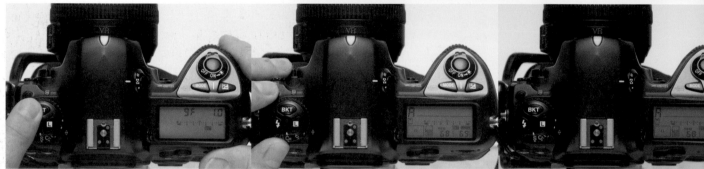

Bracketing exposures has long been the safety net in professional photography, but exposure is not the only setting that can be bracketed. This has a new relevance with digital photography because many more settings can be accessed—and therefore programmed—than was ever possible with film cameras. Bracketing these days usually refers to a special camera function which, once set up by the user, automatically fires a burst of frames, although doing it manually is still valid. You could bracket the ISO settings, for example, or the focus point, or the white balance (though for the last one shooting Raw is a more sensible option than switching through the various WB options).

However, the important twist that digital brings to bracketing is the use you can now make of the sequences. While the original idea was to choose the best from a series of frames, with digital post-production you can *combine* the frames for extreme control over the image. Combining in this case means taking the best from different frames so,

with an exposure bracket, you can assemble a single image that takes the better exposed highlights from the darker frames and the opened-up shadows from the lighter frames. The software to do this is readily available, and the method is either some form of blending, or the more complex and powerful HDRI (High Dynamic Range Imaging). This book is about shooting, and not the place to go into the details of post-production, but if you know what can be done later you can adapt your shooting technique to suit.

All of this comes under the heading of multi-shot photography.

Every digital SLR allows you to bracket your exposures, but more and more cameras now allow you to bracket other features, such as ISO or white balance. While the range of control varies from model to model, bracketing is an easy way of ensuring you get the images you want. Setting a continuous shooting mode with bracketing is also a quick way of getting a range of exposures for HDR imaging.

75

Aligned sequences

At the heart of all these multi-shot techniques—and there will be more to come—is the basic requirement of a sequence with the images in register. For certain techniques the needs are more stringent—exposure and other settings identical, with time the only variable. Zoom lenses pose a special risk, because if there is one thing that cannot change in any of these sequences, it is the basic geometry of the image. If the sequence is shot over an extended time, be careful that the zoom control is not touched. For extra safety, stick a length of tape around the edge of the zoom ring.

In terms of register, software has come to the rescue, with recent developments in image content recognition overcoming minor misalignments. One illustration of this is the Ephesus sequence here, imperfectly aligned without a tripod. The shots here were taken before the software that was eventually used to combine them was available or even known about. This is an excellent example of two other tips in this book: Shoot for the Future (#4) and Anticipate the Processing (#97). I just knew that something could be done with them later. In fact, when I first processed these images, I had to align them manually (which was tedious), and then erase through from layer to layer, which was even more of a chore. Some four years later, Adobe introduced Auto-align and Stack Mode to Photoshop, which reduced the process to less than a minute.

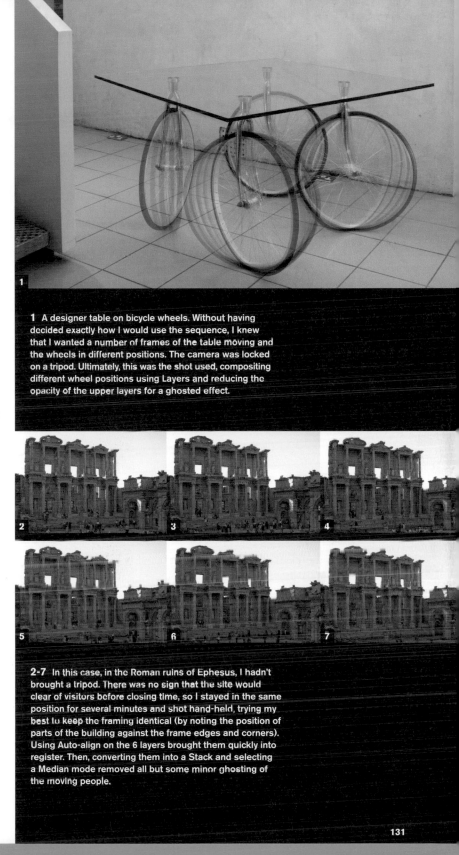

1 A designer table on bicycle wheels. Without having decided exactly how I would use the sequence, I knew that I wanted a number of frames of the table moving and the wheels in different positions. The camera was locked on a tripod. Ultimately, this was the shot used, compositing different wheel positions using Layers and reducing the opacity of the upper layers for a ghosted effect.

2-7 In this case, in the Roman ruins of Ephesus, I hadn't brought a tripod. There was no sign that the site would clear of visitors before closing time, so I stayed in the same position for several minutes and shot hand-held, trying my best to keep the framing identical (by noting the position of parts of the building against the frame edges and corners). Using Auto-align on the 6 layers brought them quickly into register. Then, converting them into a Stack and selecting a Median mode removed all but some minor ghosting of the moving people.

76

Blending exposures

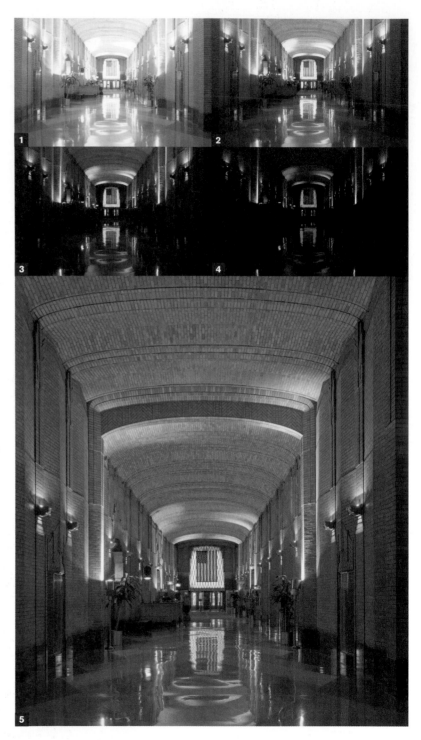

Watch this space. My prediction is that there will be more and better procedures for blending a range of exposures in order to increase the total dynamic range. The basic principle is straightforward, but the execution is often less so. In a pair of aligned exposures—one darker, the other lighter—the optimal parts of each image are combined. In a sequence of several exposures, the best-exposed areas from each are combined. This can be done in different software. Photomatix is dedicated to this and to HDR. In Photoshop, Stack Mode offers Mean and Median, which are more limited, but still useful. With the choice available it's probably better simply to click through them and see which appeals the most, rather than immerse yourself in the technicalities of algorithms.

1-5 The main hall of the Western Union building in New York is a difficult interior to photograph. It was important to be faithful to the original lighting and reflections, which ruled out adding photographic lighting, as this would have partly drowned them. Instead, four exposures were made, spaced two *f*-stops apart, from 1/3 sec to 13 sec. The darkest frame holds the highlights, while the lightest has well-exposed shadow detail. At this stage there are a number of options for combining these exposures. The one finally chosen was an Exposure Blend in Photomatix software.

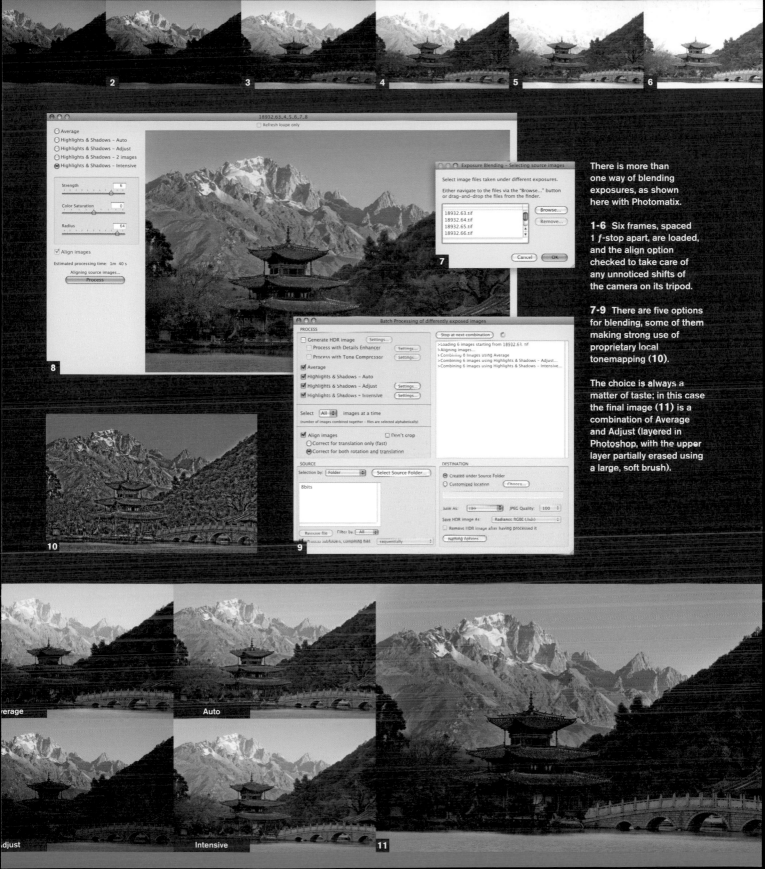

There is more than one way of blending exposures, as shown here with Photomatix.

1-6 Six frames, spaced 1 *f*-stop apart, are loaded, and the align option checked to take care of any unnoticed shifts of the camera on its tripod.

7-9 There are five options for blending, some of them making strong use of proprietary local tonemapping (**10**).

The choice is always a matter of taste; in this case the final image (**11**) is a combination of Average and Adjust (layered in Photoshop, with the upper layer partially erased using a large, soft brush).

77

HDR–from workhorse to weird

High Dynamic Range (HDR) Imaging is a system for capturing a huge brightness range in one special image file, and then processing it so that it can be viewed and used normally. "Normal" means an 8-bits-per-channel image that can be viewed on a regular monitor (8-bit) or printed (paper prints have even less range than 8-bit). HDR Imaging was developed to cope with the problems of compressing dynamic ranges that are way beyond the 8-to-9 stop range of a normal, good DSLR, and, in particular, all scenes that include the light source.

In photography, the only way to capture a high dynamic range is to shoot a sequence of exposures, typically spaced around 2 *f*-stops apart. These are then merged into a single HDR image that has 32-bits per channel. This is not viewable on a normal monitor, so the HDR image has to be compressed into a 16-bit or 8-bit image. The method used for this is called "tonemapping," and the sophisticated procedures work out the appropriate contrast and brightness for different parts of the scene. As intended, HDR solves the problem of blown highlights and blocked up shadows, but what has happened is that HDR software such as Photomatix has been taken up not for this basic purpose, but to make use of the tonemapping algorithms, which can be made to produce weird results. There's nothing wrong with that, if that's what some people want, but the core HDR use is to solve a problem.

1

4

1 A classic and necessary use of HDR—the interior of a church crypt with a dynamic range of around 15 stops.

2 HDR software can usually deal with ghosting (subject movement) by favoring one frame over others in the area of movement. It was used here for a portrait of Chinese artist Yue Minjun.

3 The dynamic range in this scene, in the courtyard of London's Royal Academy, is not overwhelming, making it more of an MDR (Medium Dynamic Range) image. Exposure blending could have been used instead.

4 Pushing the various tonemapping controls to their extremes turns this photograph from Tip #76 into a peculiar and rather gaudy image.

78

Simple HDR capture

The idea of HDR is to shoot a range of exposures, from one that holds all the highlights, to one that exposes the deepest shadows as if mid-tones. Lock down the camera if at all possible, or at least keep it steady (the software can align the images up to a point). An exposure spacing of 2 *f*-stops is sufficient; any less and you are wasting frames, although no harm comes of it. Start with the darkest exposure, using the camera's screen highlight clipping warning to gauge the exposure that holds the highlights. Increase the exposure a shot at a time, and watch the camera's screen histogram until the left edge is in the middle of the scale. A common mistake is to stop shooting too early in the sequence. The last frame should look very overexposed to the eye.

If you are relying on the HDR software to align the images, rather than using a tripod, then a faster technique is to set the camera to its widest range of exposure bracketing. Many cameras unfortunately have 1 *f*-stop as the maximum spacing, but this doesn't affect the quality of the HDR merge. Shoot at the fastest continuous speed your camera allows for close alignment.

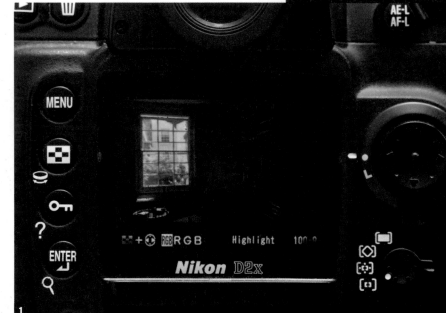

1

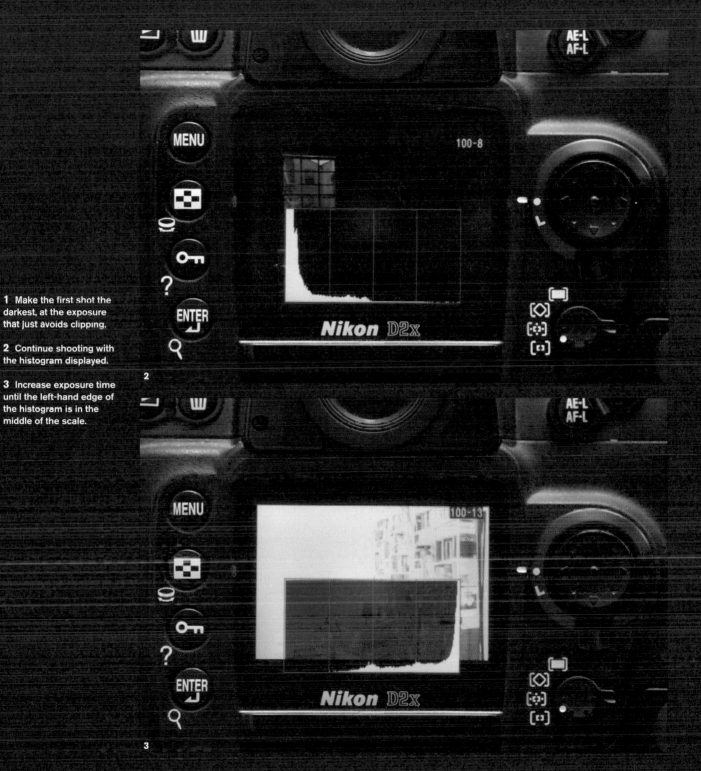

1 Make the first shot the darkest, at the exposure that just avoids clipping.

2 Continue shooting with the histogram displayed.

3 Increase exposure time until the left-hand edge of the histogram is in the middle of the scale.

79

One light, many directions

For various reasons, a useful trick is to apply different lighting to a succession of exposures, then combine them later, as a layer stack. One advantage of this working method is that you only need to carry one photographic light. The simplest light is a flash unit designed for on-camera use, but which can also be fired off-camera. I usually carry the incandescent light shown here, with lens attachments that allow precise beams.

In use, a single light can be employed to make any number of exposures, pointing it at different parts of the scene to light different areas in each shot. The multiple frames can then be combined on the computer to produce images that appear to have been lit by a number of lights. Apart from saving weight, multi-shot lighting also avoids conflict between multiple lights, and makes it possible to remove unwanted shadows and spill. At the cost of extra time in blending the shots, there is no limit to the number of "lights" you can use in a scene.

The light used for these photographs, a Dedolight, is small, compact, and capable of directing a very precise, controlled beam.

16 For this copyshot of a subtly toned painting, two frames were exposed, one with the spotlight to the left of the painting, the other with the light to the right. In both instances, the light was at an acute angle so that the beam raked the surface. A magnified detail **(17)** shows the relief of the brushstrokes, but with the highlights and shadows on these strokes reversed between the two exposures, they could be combined as layers to cancel each other out.

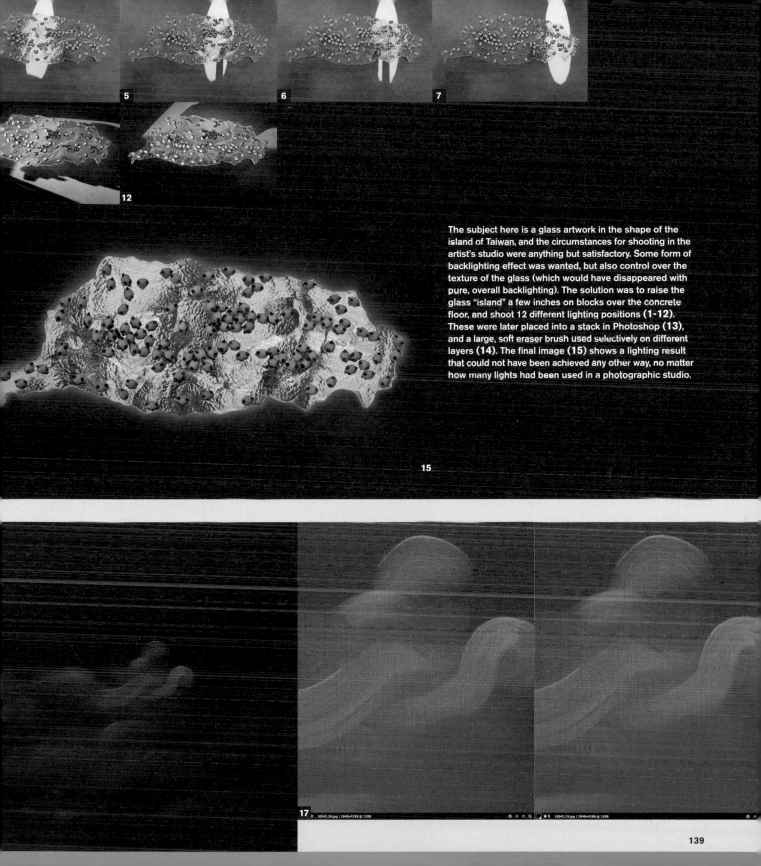

The subject here is a glass artwork in the shape of the island of Taiwan, and the circumstances for shooting in the artist's studio were anything but satisfactory. Some form of backlighting effect was wanted, but also control over the texture of the glass (which would have disappeared with pure, overall backlighting). The solution was to raise the glass "island" a few inches on blocks over the concrete floor, and shoot 12 different lighting positions (1-12). These were later placed into a stack in Photoshop (13), and a large, soft eraser brush used selectively on different layers (14). The final image (15) shows a lighting result that could not have been achieved any other way, no matter how many lights had been used in a photographic studio.

80

Noise-removal sequences

Shot noise, as opposed to dark pattern long-exposure noise, is random, and while this makes it difficult to reduce, it has one advantage—if you take several identical frames in which everything else stays the same, you can get rid of the noise precisely *because* it is the only variable. The trick is to combine the several frames by averaging, and there are different ways of doing this. There are also different kinds of average—mean average, which is what most people think of, and median average. Mean adds together the whole series and divides by how many are in the series. Median finds the most common in a series, and in principle is best for this kind of noise reduction, as it ignores the varying values caused by noise—providing there are enough exposures.

Here are two ways of processing seven identical frames. In the first, a simple Average exposure blend in Photomatix is applied. In the second, which takes rather longer, the frames are placed in a layer stack, and Median Stack Mode chosen.

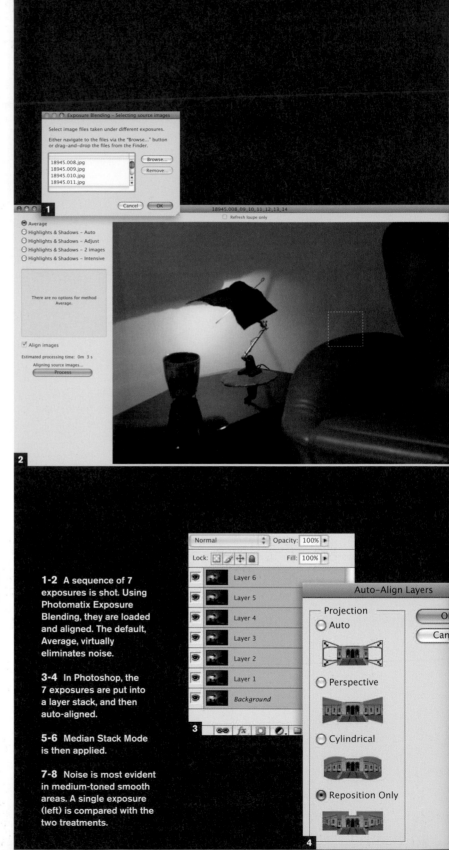

1-2 A sequence of 7 exposures is shot. Using Photomatix Exposure Blending, they are loaded and aligned. The default, Average, virtually eliminates noise.

3-4 In Photoshop, the 7 exposures are put into a layer stack, and then auto-aligned.

5-6 Median Stack Mode is then applied.

7-8 Noise is most evident in medium-toned smooth areas. A single exposure (left) is compared with the two treatments.

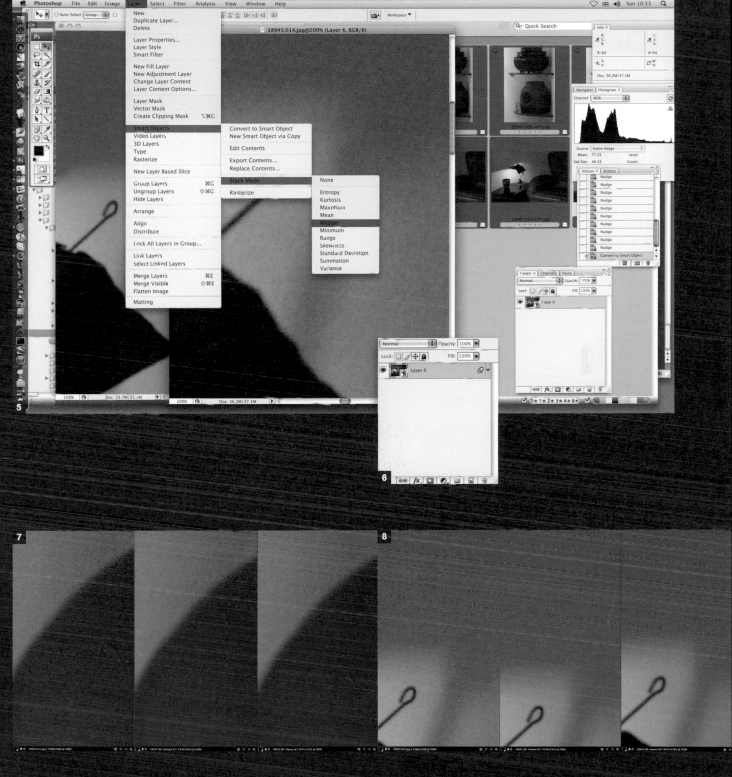

81

High-low ISO blending

Imagine you have a dimly lit scene—perhaps a night shot—that is mainly still, like a landscape or a city view, but it also contains some movement that you want to capture, such as a person walking in the frame. You could turn up the ISO to a setting that allows a fast enough shutter speed to freeze the movement, but the rest of the image would have to suffer noise.

However, it is possible to have the best of both worlds if you don't mind combining two versions of the shot. Shooting at different ISO settings loses nothing. Most of the image is captured with a slow shutter speed and low ISO, but the smaller area of motion is caught sharply enough by shooting at a high ISO. This is a slight departure from bracketing, in that the final composition has to be done by hand. Compositing in post-production is straightforward in principle—just layer the two images in register, and erase one or the other so that only the immediate noise area around the movement is used. As this area is likely to be detailed rather than smooth (otherwise there would be little reason for using this technique), the noise will probably not be objectionable. If you choose to apply any noise-removal in post-production, apply it to this layer only.

Like most multi-shot operations, this technique demands that most of the scene be static and that the frames are (more or less) in register. The example here is typical of situations that can benefit—a tripod shot of an interior in which one small area, in the bar, has movement too fast to be captured without blur at a low, noise-free ISO.

1 For this interior of a bar in Shanghai, the architectural nature of the subject and its intended use in a large-format book required high image quality, and therefore minimum noise. At ISO 100, the exposure needed at ƒ11 was 5 sec. Yet to give some natural life to the shot, I also wanted a barman in action, and this needed a shutter speed of at least 1/15 sec, even with the barman moving slowly for my benefit. This meant a sensitivity setting of ISO 1000, and inevitably noticeable noise.

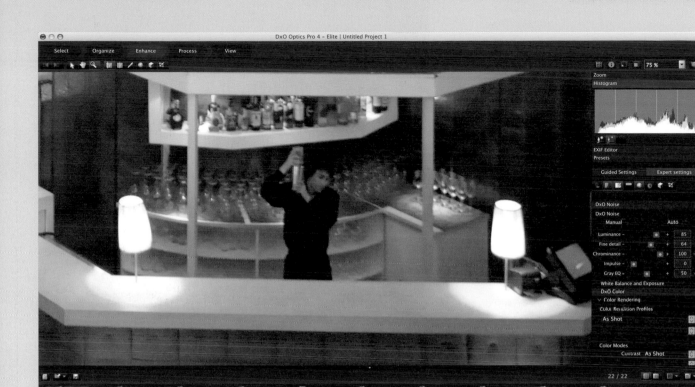

2

2 Both versions of the interior were processed to optimal quality in a Raw converter (here DxO Optics Pro).

3-4 As shot, the difference in ISO setting produced an unwanted difference in color balance, which needs to be dealt with.

5 Using Curves, the tonal and color balance of the two images are matched as closely as possible, seen here in a split view.

6 The high ISO version is placed as a layer over the low ISO version, in register. Beginning with a small brush, the area surrounding the figure in the high ISO version is erased. Following this, the brush size is increased and the remaining areas erased, until only the figure is left.

82

Crowd-removal sequences

Any unwanted moving subjects in a scene can be eliminated by the simple tactic of shooting several frames in register over a period of time. The classic use of this is to remove people from a scene, and both the principle and practice are the same as for noise removal. As long as there is enough movement so that at some point in the sequence of shots every part of the stationary setting is revealed, a median average filter will do the trick. Median, as explained earlier, is the averaging method in which the most common value is selected. In this case, that means the background.

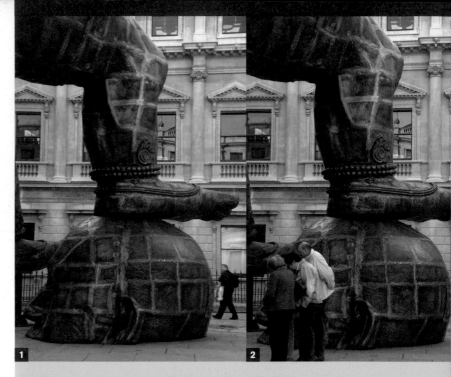

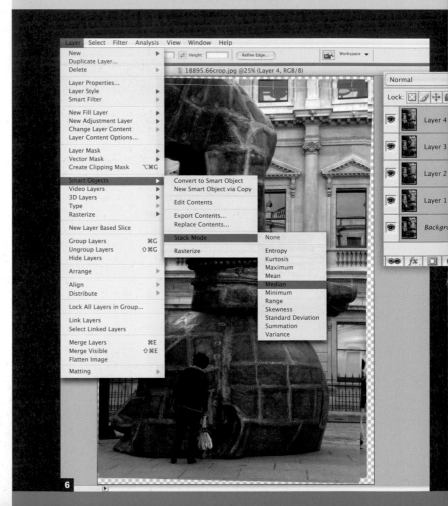

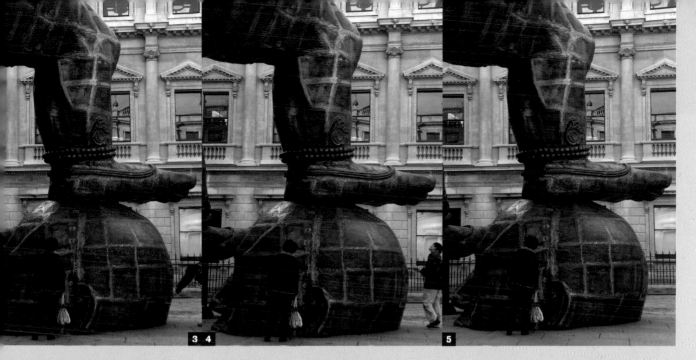

3 4

5

Opacity: 100%

Fill: 100%

Layer 6

Auto-Align Layers

Projection

Auto

OK

Cancel

Perspective

Cylindrical

Reposition Only

7

1-5 At no point was this sculpture plainly visible without people walking by, but in the course of five shots, each part was at some point clear.

6 In Photoshop, the five images are placed in a stack, aligned, and have Median Stack Mode applied.

7 The Median mode eliminates the variables, which means the spectators. Some cropping will be necessary, as the auto-alignment has caused some image shift to compensate for the hand-held sequence.

83

Infinite depth of field

Perhaps even more dramatic than the multi-shot blends just described is the blending of sharpest focus. Depth of field is usually an issue in macro photography and photomicrography, where even the smallest aperture is not normally sufficient to render everything in the field of view sharply. Even on larger scales, there are times when you have to compromise on depth of field—for instance a landscape or cityscape shot taken with a long lens and with considerable depth. With certain kinds of "stacked" telephoto shots the ideal would be full depth of field, with no part soft, but this is usually impossible by simply stopping down, as depth of focus for any lens has its limits.

An excellent algorithm comes to the rescue, which chooses the most sharply focused areas of a sequence of images in which the lens focus is racked forward or backward. This is by no means a simple software achievement, as the act of changing the focus also changes the relative scale of objects in view. The software featured here is Helicon Focus, which is dedicated to this task, with an extremely simple interface and seamless performance that belies the problems of matching, scaling, and blending.

The shooting procedure is to lock the camera down on a tripod, set focus to manual, begin at one focus point—either the nearest or furthest—and then shoot a series with small changes of focus in between. The closer the spacing of the focused points, the more accurate the final blend will be, so

it's a good idea to shoot a wide number of frames. Because the software can handle any number of frames in a sequence, image quality is better if you shoot stopped down only a few stops from maximum; this avoids the usual loss of resolution due to diffraction.

The beauty of this technique is that there is no retouching, no fabrication, and no Photoshop alteration. It's pure capture, just handled by a sophisticated blending procedure. There are many creative possibilities, but there is a also a warning. In a long sequence (meaning a long focus rack from front to back), strong highlights may blur so much that they "leak" over the sharply focused edges, requiring a second blend using a shorter range of frames to solve the problem.

Macro pen
A fountain pen photographed with a 105 mm macro lens. The nearest point of focus (the tip of the nib) is the closest focus point possible with this lens—13 mm from the front of the lens. The focus was then racked approximately 1.5 mm at a time over 98 frames, covering a total focusing distance of 150 mm. Shooting 98 frames may have been overkill, but this is safer than over-spacing and getting soft zones in the final image. The aperture was set to ƒ11 for good resolution and a modest depth of field.

Make movies

1 A night scene looking over the old Yunnanese town of Lijiang, floodlit, as the moon sets. First, a few shots were taken at an interval of 5 minutes, to gauge the angle of the moon's apparent descent. This assisted the framing, which had to include the point on the skyline where the moon finally set. Almost 100 frames were shot over a half-hour period, at 20-second intervals, beginning a few minutes before the moon appeared at the top of the frame, and ending after it had set and the last glow of its halo had disappeared.

2 Using FrameThief on an Apple Mac, the frames were combined into a QuickTime movie.

The software for combining frames into movies is widely available, and varied. If you have a slowly changing scene, or have a way of moving the camera smoothly, a step at a time, then time lapse sequences can be turned into impressively high quality movies. A 10-megapixel camera produces an image measuring approximately 3000 x 2500 pixels, which exceeds the natural resolution of a 1080i/p High Definition Television (1920 x 1080 pixels). The image quality, particularly if you shoot Raw and process carefully, can be spectacular. All you need is the patience, a tripod, and a scene in which you can predict the way the composition may change as time passes and things move. The possibilities are endless. The example here was a night view of the moon setting from my hotel room.

I had the idea to do another example, of something decaying, when I realized that this might take a week or two and this book couldn't wait.

The simplest and crudest technique is to use a watch and just trigger the shutter release at a fixed rate. Some cameras, however, have a time-lapse mode, like a built-in intervalometer. Playback doesn't involve particularly expensive, or specialist software, in fact, you may already have it on your computer. Adobe Photoshop Elements 6.0 (for Windows) features a "Flipbook" option for combining, viewing, and saving multiple images and there's also "freeware" available such as Monkey Jam and "shareware" such as the $40 FrameThief. A search on the internet for "Stop Motion Software" will reveal even more options to suit all operating systems and budgets.

Chapter_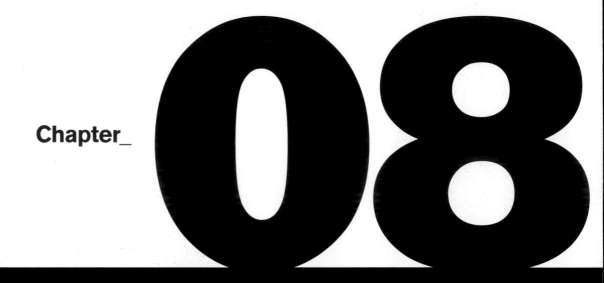

Low-light

90 91 92 93 94 95

85

Right camera, right sensor

Photons of light traveling from the lens

Microlens
Color filter
Metal opaque layer
Photodiode
Silicon

1

APS-C

Full Frame

2

Recently, there have been some sophisticated developments in sensor technology, both in their manufacture, and in the ways the image information is taken off the sensor. The result is that cameras are definitely not equal when it comes to their low light performance. In this instance, "performance" primarily means noise effects, and the inescapable truth is that the best way of guaranteeing images with less noise at high ISO settings is to buy the right camera. This means, as you might imagine, a costly top-of-the-line model, unpalatable though this may be. There may be all kinds of ways to make things better with the camera that you have, but the most effective solution is to spend the money wisely at the outset.

It would be unrealistic to give a ranking here and now of camera models, as they change rapidly, and often without warning. However, it is worth understanding the difference that the size of a sensor makes, especially as more and more manufacturers are now producing "full frame" cameras with 24 x 36 mm sensors, as opposed to the non full frame cameras that dominated the market in recent years. Without getting too technical, the laws of physics are unforgiving, and the size of a sensor has a direct impact on the size of its light sensitive photosites. The same number of photosites (meaning pixels) in a larger sensor allows each one to be bigger than it would be on a non full frame camera. That means the photosites can gather more photons, and are less susceptible to noise. The

result is not only that higher ISOs can deliver relatively noise-free results, but shooting at very high settings, like ISO 3200 or above, has became practical, as well as useful.

This is all very well, but how do you *know* what the practical differences are going to be between a choice of cameras? Obviously, be careful in accepting the manufacturers' claims, because you will certainly never hear the drawbacks. Independent reviews are the best source, and those that show side-by-side comparisons of images at magnification from different cameras will let you see clearly how two or more models compare. Ultimately, as with most imaging issues, you must rely on your own eye. The next step, once you have narrowed the choice, and if you are buying from a store rather than on-line, is to persuade the dealer to let you try out the different cameras. This is easy enough to do right in the store. Just take along a memory card and shoot the same sequence of images at a range of ISO settings with each camera. Take them home and examine them side by side. The differences in noise that you personally notice are the only ones that count.

1 Every pixel in an image is generated by a photosite on the camera's sensor. Light coming through the lens creates a charge in a photodiode, and this charge is converted into digital information. The bigger the photosite, the better it is at recording information, and the less noise there will be in your images.

2 A full frame sensor allows the camera makers to use bigger photosites than they would on a non full frame camera (assuming the same pixel count on both), which means less noise in the images.

Decide your priorities

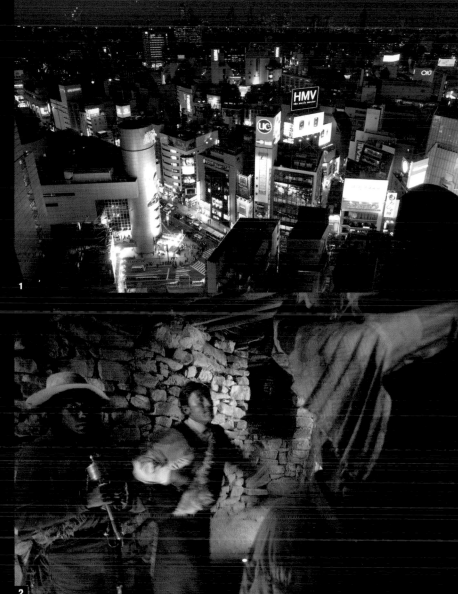

1

2

Low-light photography is specialized in that you are always pushing the technical limits. By definition, there is never quite enough light to allow the ideal camera settings, and you will always forfeit something. This area of shooting is all about thresholds and tradeoffs. There are three main technical variables—shutter speed, aperture, and ISO—and you will need to decide which has priority. The key to technical success in low-light photography is to know what the acceptable thresholds for each of these is for *you*. This means familiarizing yourself with, at the very least, the noise characteristics of your camera, your ability to hold the camera steady when hand-held, and the shutter speed needed for any kind of movement in the frame. Then you have to prioritize, and that depends on the situation and on what you personally are prepared to accept as minimum image quality. Some motion blur might well be acceptable, depending on where it happens in the frame and how it looks, or you might prefer more noise in order to avoid this. Only you can make these decisions.

Because noise is a relatively new thing from digital photography, it gets a lot of attention, which is fine, but when set against camera shake, subject motion blur, and the difficulties of achieving sharp focus with wide apertures, it is not the only image quality issue to deal with. A noisy image from a high ISO setting is at least a workable, recognizable image, while the alternatives—blur or underexposure—are useless.

1 For this nighttime cityscape, a low ISO to avoid noise was the main priority, as well as a small aperture for good depth of field. This meant putting the camera on a tripod to prevent any camera shake during the long exposure.

2 Shooting hand-held under low ambient lighting conditions required a relatively fast shutter speed to avoid as much camera shake as possible. This meant using a fast ISO and accepting that there would be noise in the image.

87

Noise reduction

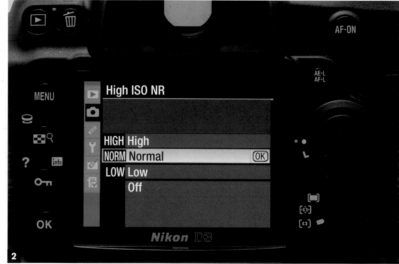

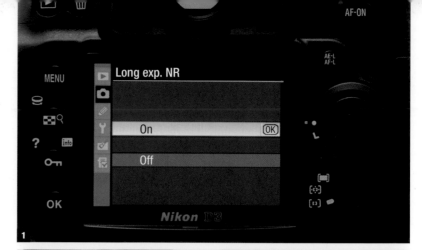

For photographers, noise is a matter of appearance, and this is a slightly different way of looking at it from the science and technology. I can illustrate this with a simple example. If you have a noisy image, but reproduce it so small that you can't see the noise, does it matter? Of course not. As a photographer, it may help to think about noise as how it looks, rather than how it was created.

Related to this is how the image will eventually be displayed, which may be quite different to your post-processing view on the computer screen. At 100% magnification on-screen, any significant noise will look obvious, but if the image is intended for printing—as with a gallery print, or in a magazine or book—the intervention of ink on paper (and of paper texture) will almost always reduce its appearance.

The following is a list of different ways of reducing the appearance of noise. Some of them can be used in combination, and each is dealt with in more detail later:

1 Use the lowest ISO that a reasonable shutter speed and aperture will allow (see Tip #88).
2 Use a fast lens (see Tip #90).
3 Use the image small (see Tip #93).
4 If printing, consider textured paper.
5 Turn the camera's noise-reduction systems on for both high ISO and long exposures.

6 For a static subject, use a tripod and a longer exposure at a low ISO (see Tip #92).
7 Take multiple shots and run them through a median or ghosting filter (see Tip #80).
8 Use good Raw conversion software with a sophisticated de-mosaicing procedure (see Tip #98).
9 Apply noise reduction software in post-processing (see Tip #99).
10 Shoot a stitched mosaic for a larger image file (see Tip #69).
11 Shoot high and low ISO versions, and combine selected areas later (see Tip #81).

1 Most cameras have built-in noise reduction, but the fact that the user is offered a choice should alert you to the potential issue that the process may involve some blurring and loss of detail. Do a test at a high ISO on a scene with featureless mid-tone areas, with and without this option, and then decide for yourself.

2 Noise caused by a long exposure is best removed at source—i.e. in the camera. The only cost is having to wait the same amount of time as the exposure while the camera takes a "dark frame" for the removal process.

88

Know your camera's noise potential

I deal quite a lot with noise in this chapter, because it's an issue that concerns every digital photographer who shoots above the ISO baseline, and many of the discussions are fairly general. But, in the end, the only thing that matters is how the noise from *your* camera looks. And, because noise is basically signal failure, and is not structurally part of the recording medium (like film grain), it differs from camera to camera. Surprisingly, many photographers take their noise advice at face value from the manual, reviews, or online forums. In fact, the only way to understand what the problems are, and how much they might matter, is to spend time testing your own camera.

The test here concentrates on a dark area without detail (the shadow on a wall that is out of focus), because the noise at different ISO settings can be seen most clearly under these conditions. However, you might also want to focus on some detail and edges, and indeed on the kinds of features that most disturb you in your type of photography.

1 Shoot any scene that contains a mid-to-dark-toned, smooth area that will reveal noise at its most prominent. With the camera on a tripod so that all the exposures are in register—for useful comparison later—make a series of shots at all the ISO settings available on your camera. Crop the detail and process identically (here using a Raw converter), with any noise-reduction filters turned *off*.

2 I made the same test with three different cameras, and was particularly interested in seeing if Nikon's noise claims for the D3 stood up. They did. Note that the noise patterns differ, helping to make noise assessment subjective (to a degree). To my eye, the noise in this kind of image area from the D3 at ISO 6400 compares with ISO 1600 from the D200.

3 An available-light shot at ISO 6400 from a Nikon D3 with, to many people's judgment, acceptable noise levels.

Ad hoc supports

Use a little imagination to make use of whatever steadying surface or aid is around. Provided that you can frame a reasonable shot, pressing the camera against any solid surface is almost the equivalent of using a tripod. It could be a railing, wall, streetlamp, vehicle roof, or even the ground. Some form of cushioning is the one accessory that you need to bring to the occasion, such as a soft shoulder bag, well-folded jacket, or even a shoe. Shown here is a plastic bag filled with rice, but you could just as well use polystyrene packing chips. Press the camera down on the cushion.

1 Traveling light often means leaving your tripod at home, but that doesn't mean you can't support your camera to avoid camera shake. Here I just pressed it into my camera bag, using it like a bean bag.

2 A quick DIY version of the bean bag. All that is really needed to give fairly solid support to a camera is a sealed bag filled with any aggregate that can be compressed to hold its shape while under pressure. This is a food bag filled with uncooked rice.

90

Fast lenses

1 A medium-long 85 mm lens, with an ƒ1.4 aperture. It's a manual focus lens, which might seem perverse these days, but the optic is excellent when shooting "wide open."

I wrote earlier about the tradeoffs between shutter speed, aperture, and ISO. If depth of field (controlled by aperture) is not an issue, then one of the best things you can do for your low-light shooting is to buy the fastest lens available. Fast means a maximum aperture of at least ƒ2, and more likely ƒ1.4. Interestingly, in these days of excellent zoom lenses with often huge ranges and good resolution, one of the qualities that is often sacrificed is maximum aperture. I have one extremely useful zoom lens that goes from 18 mm to 200 mm, and I use it a great deal, but fast it is not—ƒ3.5 at best, ƒ5.6 at worst. Fitting the camera with a Zeiss 85 mm ƒ1.4 Planar, which I use more in low light, is like a revelation through the viewfinder. It reminds me how easily I've become used to slow zooms.

Of course, to get the most value from a fast lens you do actually need to shoot at full aperture,

and this brings another reminder, often painful, that correct focus wide open is critical. Low lighting can adversely affect the camera's auto-focusing, but perhaps more important is making sure that the right part of the scene is sharply focused. With such shallow depth of field this becomes much more of an issue than usual.

2 A hand-held night shot of a fishing boat taken from the rocking deck of another using the Zeiss ƒ1.4 at full aperture. Perhap surprisingly, the ISO needed for this was only 320.

91

Shoot for detail, not for smooth

Spend any time dealing with noise in high-ISO images and you learn very quickly that the problem areas in a photograph are the smooth ones. They are smooth either because the subject has little detail (such as a sky), or smooth because the area is defocused, as happens in the background of a wide-aperture shot taken with a telephoto lens. You may have a harder time sorting out noise from detail in busy, high-frequency areas of an image, and that naturally means the noise matters less.

Indeed, at a certain point noise is usually indistinguishable from detail, and this is all to do with frequency. Smooth, low-detail areas are low-frequency. Detailed ones, as in the examples here, are high-frequency. Noise that makes itself obvious and objectionable across distances of just a few pixels is also high-frequency. Following the principle that noise matters only if you can see it, busy areas of a photograph can usually be left alone.

These lessons can be carried over into shooting. If the scene is full of busy detail, noise will matter little. For lenses, this tends to favor wide-angle, with their naturally better depth of field. Unfortunately, fast lenses used wide open, and particularly if they are medium or long focus, tend to be used in situations when you can expect smooth areas from soft focus. Nevertheless, composing in such a way as to fill the frame with detail, which may take no more than shifting your position a foot or two, will usually help.

1 Although there are a few smooth, low-frequency areas, such as the men's shirts, most of this scene, shot from close with a wide-angle lens at 15 mm and with good depth of field, is full of detail, and this generally swamps the noise, which at ISO 25,600 is significant.

2 An excellent example of what not to shoot at a high ISO (12,800 in this case). The largely featureless night sky, fairly dark, shows up all the noise artifacts mercilessly. Images like this need noise reduction in post-processing.

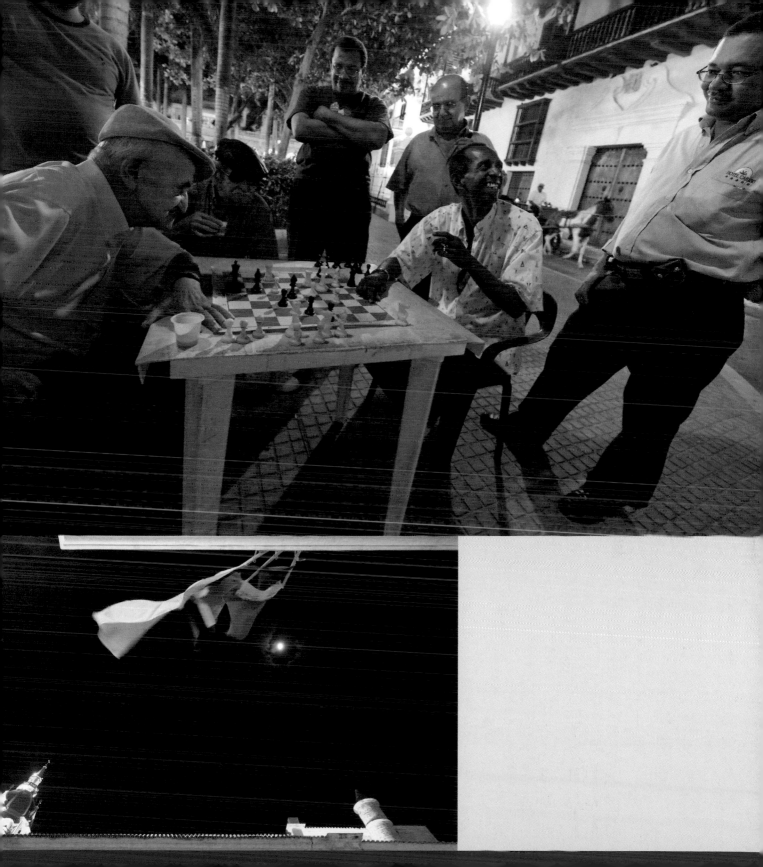

92

Hand-held or locked down

There are two completely distinct and different approaches to shooting in low light, each calling for its own techniques and equipment and suiting particular subjects. One is hand-held, trying as much

as possible to shoot as if in normal lighting, while the other is locked down on a tripod. Because the equipment is different, particularly whether or not you use a tripod, you need to decide *before* setting out on a night shoot or similar which way you want to go.

1 This is the kind of night shot that you would want to be noise-free and sharp throughout, with the pardonable exception of streaking traffic lights. The Shanghai Bund, here photographed with a reasonably long focal length of efl 250 mm, on a tripod.

2 Hand-held night-time shooting tackles quite different subjects—here emergency crews on a Saturday night in

Bangkok—with different expectations of image quality and noise.

3 Some cameras feature an auto-ISO setting, in which you set the lower limit for shutter speed and the upper limit for ISO sensitivity. Once the available light levels breach the shutter speed limit, the camera automatically adjusts the ISO upwards. This is invaluable for hand-held shooting without delays.

93

Noise depends on image size

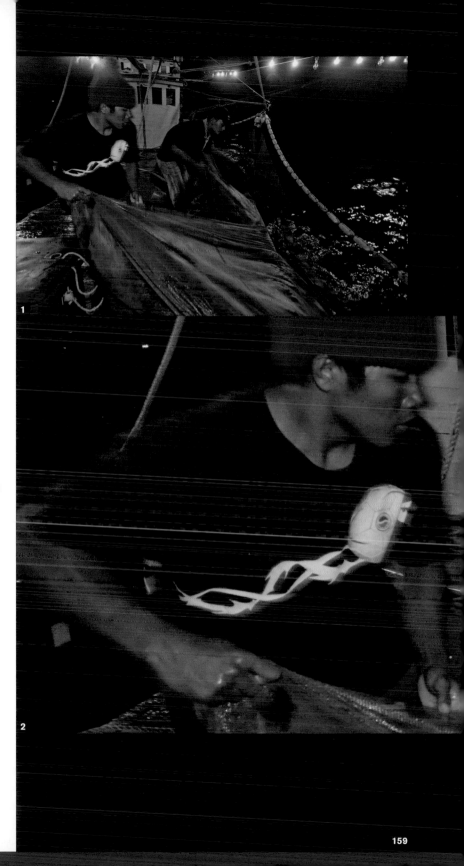

1

This is obvious enough, but highly influential if you have complete control over how the image will be used. Because noise is an error, or at least a deviation at pixel level, it becomes most visible and objectionable when enlarged. A noisy image from a 10- or 12-megapixel camera reproduced as a magazine double-page spread will *look* noisy, but at a quarter-page may show no noise at all.

By the same token, a large sensor, such as on a digital camera back, gives a higher resolution than a typical SLR, and so an image taken at the same ISO and reproduced at the same size will show less noise. If you stitch frames together for a larger image (see Chapter 6), this will also help, but it all depends on being able to decide the reproduction size. Professionals tend not to have this luxury.

1-2 Shot at ISO 1000, this night-time scene on a squid boat, alleviated by a little supplementary flash, has noticeable noise in the smooth areas such as flesh tones, but this becomes insignificant at the smaller size reproduced.

2

94

Night shooting gear—hand-held

The priority is staying light, mobile, and flexible. If you forgo the obvious benefits of a tripod, the reward is shooting simply, quickly, and on the move. There are infinite configurations, but this is mine:

* SLR (in this case one that performs well, with little noise at high ISO settings) with a fast lens (f1.4)
* Wide-angle zoom with a good maximum aperture (f2.8 in this case). Longer focal lengths are less easy to use hand-held at slow shutter speeds.
* Camera-mountable flash
* Flashlight
* Spare memory card
* Hand-held exposure meter. A little old-fashioned in these digital days, but valuable for assessing the overall light levels and dynamic range in a scene.

* Plastic zipable food bag filled with rice, on which to rest the camera for longer exposures. It could also be filled with beans or polystyrene, or anything that absorbs small movements, but rice happened to be handy. Otherwise, use your camera bag.
* Small, light shoulder bag

95

Night shooting gear—tripod

Shooting with a tripod slows everything down, from setting up the shot, to the exposure itself, but it does suit certain kinds of scene. As you will be carrying additional equipment—quite possibly on your shoulders or back—you need to be prepared for that, so the tripod design and model is critical.

This one is made from carbon fiber and a make I've always used. It's light (but strong), with three-section legs and a center column that takes it up to my head height. Mine is fitted with a quick-release plate on a magnesium-alloy ball-head, and a quick-release carrying strap that I find faster to use than a tripod case. It also makes a big difference to be able to shoulder the tripod, rather than carry it all the time in one hand.

* Cable release
* Flashlight
* Hand-held exposure meter, here fitted with a spot attachment for measuring small areas of the scene
* Wide-angle zoom lens
* Telephoto lens, here 300 mm with a modest maximum aperture, but much less bulky than a fast monster
* SLR with a fast lens and an L-bracket that attaches to the tripod's quick-release plate. The shape of the bracket, which wraps around two sides of the camera, makes it easy to shoot vertical format as well as horizontal images
* Spare memory card
* Shoulder bag

Chapter_ 09

Processing

96

Assemble the right software

Why does processing qualify for a mention here, in a book on shooting? Because in digital photography, shooting involves anticipating what comes later. If you know exactly what can and cannot be done at the processing stage and in post-production, then you can shoot with more confidence; you can take certain risks in shooting while avoiding being tempted to take others. Some software allows good results to be pulled out of seemingly unpromising image files, so having the right suite of software to process your images is an important part of the full process of digital photography, and for this reason alone is intimately connected with shooting.

There are some areas in which different software companies compete, and where some are objectively better than others, but on the whole your choice of software should be influenced by

your own style of working, and your preferred type of photography.

I'm not making any recommendations, but this is the software that I normally use. Some of it is used regularly, and some of it only occasionally for special needs or in emergencies. Photo Mechanic is used for downloading files to the computer and as an image browser; Expression Media as a database for organizing, captioning, and general housekeeping; DxO Optics Pro for primary processing; Adobe Photoshop for most post-production work; Photomatix when HDR and exposure blending is involved; Stitcher for stitching; Noise Ninja for serious noise reduction, PhotoZoom for upscaling images; Focus Magic for repairing soft focus; iPhoto for posting images on the Web for client review, and Fetch for FTP uploading. That's just my way of working, though, and your needs may be different.

1-4 Four of the software applications that I use consistently: Photoshop ACR, Photo Mechnaic, Expression Media, and finally Stitcher.

97

Anticipate the processing

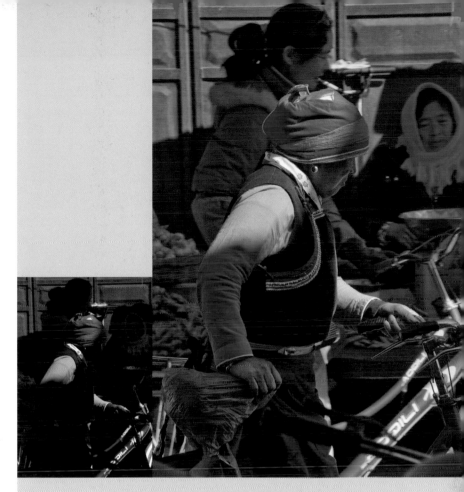

A very high contrast scene, with high-altitude clear sunlight, in a partly covered market. Without taking into account post-processing, you might think twice about shooting at the moment when one figure is partly sunlit (it would be safer to have everything in shot under shade). The JPEG, saved at the same time as a Raw file, is unaltered and shows the problem clearly. The TIFF file has been processed first in ACR, using high Recovery and Light Fill and some local exposure retouching to dodge the woman's face and hands, then a second time using Photoshop's Shadow/Highlight tool.

There was a time when processing was what a photolab did. When color film ruled photography (from approximately the 1960s to the end of the millennium), and in particular when Kodachrome was the professional's film of choice, a photographer's work ended the moment the shutter was released.

Now, digital processing is a much more intimate part of the photographic experience. Sensors capture light in a grid, and not only does this raw capture need to be processed into a readable pattern of tone and color, but it can be interpreted in many ways. The software for processing images, in particular Raw images, continues to evolve, with ever-more sophisticated algorithms that can perform minor wonders.

One prime example is local tonemapping, which is embedded (without the name) in an increasing range of software. This is a procedure for adjusting the local brightness in an image, according to the values of the surrounding pixels, so tones in a shadow area can be adjusted independently from those in the highlights. With some stretch of the imagination you could think of this as a kind of digital equivalent to dodging and burning. Knowing what this can do, you might be happy to backlight a model without resorting to flash when you shoot.

One of the simplest and most effective procedures is the auto-recovery of burnt-out highlights. This now features in all Raw converters, and works by attempting to reconstruct detail in all three color channels by using data that survives in

only one or two of the channels. Familiarity with it, and knowing just what it can effectively recover, may allow you to give just that little bit more exposure in a high-contrast situation.

There are, in addition, all the varied tips and tricks involving processing that went into the earlier chapters of this book.

It boils down to this: know what's possible, and know what can be recovered.

98

Raw converters are not equal

As another reminder that digital photography inevitably extends well beyond shooting, there are software wars going on for the prize of getting the best out of your images. The battleground is the Raw file, otherwise known as the image just as it is captured. It would be convenient if it didn't make much difference which software you used to convert your Raw files, but it increasingly *does* matter. Yes, we're photographers, not software engineers, but right now there are development teams working on ways to make the images *that you have already shot* sharper, more accurate, less noisy, and, in general, the way you would like them to be. One example is de-mosaicing, which is what all Raw converters must do in order to calculate the missing colors for each pixel (sensors are monochrome and overlaid with an RGB mosaic filter). There are endless differences in how this can be interpreted and, if you value the appearance of your photographs, you really cannot ignore this.

Patterns with spacings close to one pixel are a challenge to the de-mosaicing algorithms in Raw converters, and are prone to artifacting. Of these five Raw converters, only Photoshop ACR 4 and DxO Optics 5 successfully interpret the fluting on the columns of the Louvre in Paris. Nikon NX, Bibble and Capture One 4 all show some misinterpretation, and Nikon and Bibble both introduce color artifacting as well. You might have expected the camera manufacturer, Nikon, to be in the best position to manage this with its software, but this is clearly not the case here.

1 Adobe Camera Raw
2 Bibble
3 Capture One
4 DxO Optics Pro
5 Nikon NX

99

Recovering highlights and shadows

This is probably the most-used software procedure with images shot in conditions that tax the camera's dynamic range—high-contrast scenes, in other words. The fact is that this *can* be done digitally, and while in a pure sense the dynamic range of your camera sensor remains as it is, the practical benefit is that you can shoot with more latitude than might be expected.

The two ends of the scale—highlights and shadows—call for different treatments because of the way the sensor records them. Highlights become blown (clipped) when the photosite reaches what is called "full well capacity," and it tends to fill up in a linear way, without that forgiving tailing off that photographers were accustomed to with film. Put crudely, this means that highlights clip easily and quickly.

There are two approaches to recovery, and the first is to shoot Raw to make use of the extra bit-depth, and use the Raw converter's Exposure slider. Keep the highlight clipping warning *on* in the Raw converter, and you will see the clipped areas reduce as you lower the slider.

The second approach is to make use of your software's highlight recovery algorithms, which vary between programs, but work by using whatever values are available in any one of the three color channels (red, green, and blue) to rebuild detail. For example, although the red and green channels may be clipped, there might be something of use left in the blue channel.

The shadow end of the scale does not clip so easily, as the response curves slope more gently. However, noise increases, so shadow detail more than any other area is plagued by noise that becomes all the more exaggerated when opened up in processing. As with highlights, shoot Raw and you can recover shadows to an extent with the Exposure slider in the Raw converter, but you will also probably have to work on the noise. In addition, image-editing software also includes various algorithms for opening up shadows and, using local tonemapping, increasing the contrast just in these areas.

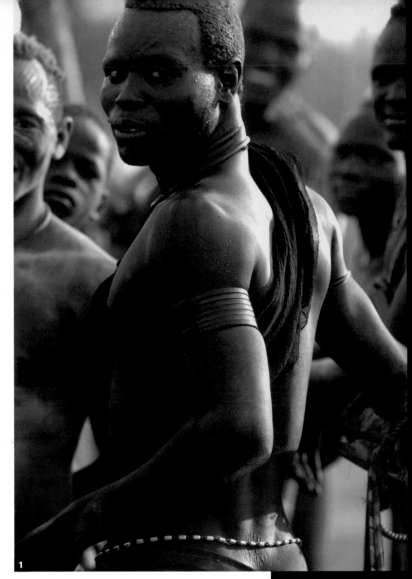

1

1-3 As shot, the highlights on the skin of this Sudanese man, as well as the sky, are clipped. This by no means kills the picture, but could do with some improvement.

4-5 Simply taking the Recovery up to close to maximum clears most of the clipping. Note, however, that while some detail has been reconstructed—most notably on the shoulder muscles and neck—the brightest areas are beyond recovery, even thought their values have been brought down from 255 to 253-4.

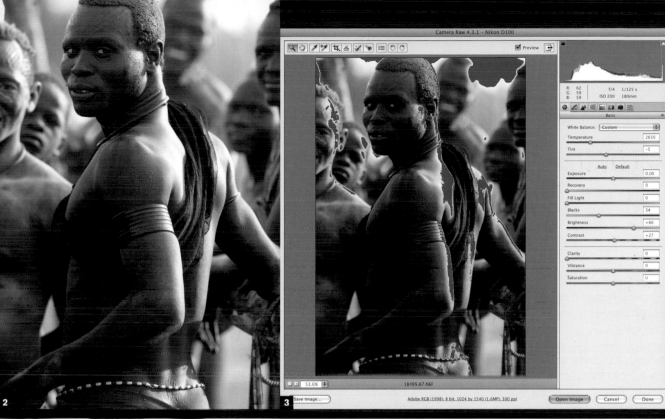

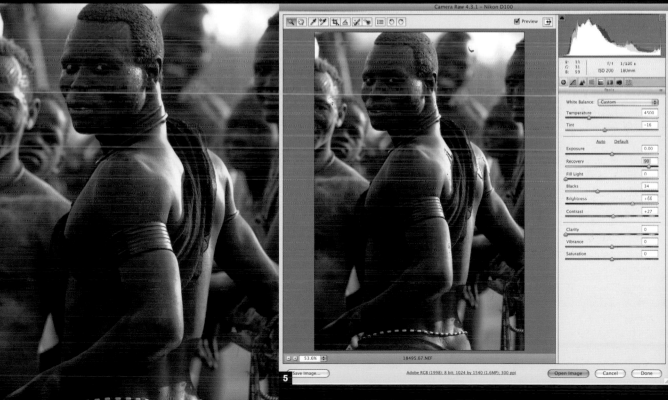

100

Caption and keyword

Most photography has a subject, and every image deserves a description. Digital imaging facilitates this wonderfully, because you can easily add and embed information in the image file. Almost all software that handles images allows you to write and read this Metadata, from Photoshop to databases. The issue is not *how* to do it, but what to add, and when.

The "what" varies according to the type of shot. A studio portrait needs the name of the sitter, the date, and not much else, but a shot of a goal in football calls for a great deal of detail. With this in mind, you can do worse than follow the old journalistic list of the five Ws:

* Who
* What
* When
* Where
* Why

Another useful tip is to write two-sentence captions; the first containing the key description, and the second expanding on this and giving background. Users can ignore the second until they need it.

On a practical and financial note, if you aim to sell images as stock in an online stock library, they are useless (indeed, unacceptable) without a caption and keywords, as search engines depend on them. Effective keywording for this purpose is a specialized skill in its own right, involving a good knowledge of how prospective clients are likely to conduct searches.

Consider the following keywording tips:
* Too many keywords is as bad as too few. Aim for no more than 10.
* Put yourself in the mind of someone searching; what words are they likely to use?
* Include different spellings and usages (e.g. petrol/gasoline).
* Include common misspellings.
* Include the plural, but not if it simply has an "s" added.
* Consider adding synonyms (use the thesaurus tool in a word-processing program).

Two of many programs that allow captions and keywords to be entered and embedded in an image: the IPTC Info window for a browser (Photo Mechanic), and the Media Info panel in a database (Expression Media).

101

Managing EXIF data

1 Date changes are often available in software such as this database, Expression Media.

2-3 EXIFRenamer, shareware with a simple interface.

4-5 Fast command-line changes to a comprehensive range of EXIF data is possible with EXIFutils. No easy user interface, but certainly powerful.

Every digital photographic image file has details of the camera settings, such as the time, date, ISO, shutter, aperture, and more embedded in it. All this is recorded in EXIF (Exchangeable Image File) format, which is an industry standard. This is not easily editable, as it is designed to be a permanent record, but there are times and reasons for wanting to change or conceal some of these details. Probably the most common is getting the time wrong by forgetting to change the time zone in the camera's menu (I should know better, but I do it almost all the time). Another is adding details that were unrecorded because, for instance, you used an old, manual focus lens.

Some browsing and database software (such as Expression Media) includes a function for changing the capture date and time, which is the most common need. Beyond this, things get specialized, and the most powerful editing software remains, to date, command-line applications, which not everyone is comfortable with. But if you are, this is the fastest way to go. EXIFutils is notable, while software with an interface includes Opanda PowerEXIF Editor. New software is constantly appearing, so check first.

Glossary

aperture The opening behind the camera lens through which light passes on its way to the image sensor (CCD/CMOS).

artifact A flaw in a digital image.

backlighting The result of shooting with a light source, natural or artificial, behind the subject to create a silhouette or rim-lighting effect.

bit (binary digit) The smallest data unit of binary computing, being a single 1 or 0.

bit depth The number of bits of color data for each pixel in a digital image. A photographic-quality image needs eight bits for each of the red, green, and blue channels, making for a bit depth of 24.

bracketing A method of ensuring a correctly exposed photograph by taking three shots; one with the supposed correct exposure, one slightly underexposed, and the final one slightly overexposed.

brightness The level of light intensity. One of the three dimensions of color in the HSB color system. See also Hue and Saturation.

byte Eight bits. The basic unit of desktop computing. 1,024 bytes equals one kilobyte (KB), 1,024 kilobytes equals one megabyte (MB), and 1,024 megabytes equals one gigabyte (GB).

calibration The process of adjusting a device, such as a monitor, so that it works consistently with others, such as scanners or printers.

channel Part of an image as stored in the computer; similar to a layer. Commonly, a color image will have a channel allocated to each primary color (e.g. RGB) and sometimes one or more for a mask or other effects.

cloning In an image-editing program, the process of duplicating pixels from one part of an image to another.

CMOS (Complementary Metal-Oxide Semiconductor) An alternative sensor technology to the CCD, CMOS chips are used in ultra-high-resolution cameras from Canon and Kodak.

CMYK (Cyan, Magenta, Yellow, Key) The four process colors used for printing, including black (key).

color gamut The range of color that can be produced by an output device, such as a printer, a monitor, or a film recorder.

color temperature A way of describing the color differences in light, measured in Kelvins and using a scale that ranges from dull red (1900 K), and through orange, to yellow, white, and blue (10,000 K).

compression Technique for reducing the amount of space that a file occupies, by removing redundant data. There are two kinds of compression: standard and lossy. While the first simply uses different, more processor-intensive routines to store data than the standard file formats (see LZW), the latter actually

discards some data from the image. The best known lossy compression system is JPEG, which allows the user to choose how much data is lost as the file is saved.

contrast The range of tones across an image, from bright highlights to dark shadows.

cropping The process of removing unwanted areas of an image, leaving behind the most significant elements.

depth of field The distance in front of and behind the point of focus in a photograph, in which the scene remains in acceptable sharp focus.

dialog box An onscreen window, part of a program, for entering settings to complete a procedure.

diffusion The scattering of light by a material, resulting in a softening of the light and of any shadows cast. Diffusion occurs in nature through mist and cloud cover, and can also be simulated using diffusion sheets and soft-boxes.

digital zoom Many cheaper cameras offer a digital zoom function. This simply crops from the center of the image and scales the image up using image processing algorithms (indeed the same effect can be achieved in an image editor later). Unlike a zoom lens, or "optical zoom," the effective resolution is reduced as the zoom level increases; 2× digital zoom uses ¼ of the image sensor area, 3× uses 1/9, and so on. The effect of this is very poor image quality; Even if you start with an eight megapixel sensor, at just 3× digital zoom your image would be taken from less than one megapixel of it.

DMax (Maximum Density) The maximum density—that is, the darkest tone—that can be recorded by a device.

DMin (Minimum Density) The minimum density—that is, the brightest tone—that can be recorded by a device.

edge lighting Light that hits the subject from behind and slightly to one side, creating flare or a bright "rim lighting" effect around the edges of the subject.

feathering In image-editing, the fading of the edge of an image or selection.

file format The method of writing and storing information (such as an image) in digital form. Formats commonly used for photographs include TIFF, BMP, and JPEG.

fill-in flash A technique that uses the on-camera flash or an external flash in combination with natural or ambient light to reveal detail in the scene and reduce shadows.

fill light An additional light used to supplement the main light source. Fill can be provided by a separate unit or a reflector.

filter (1) A thin sheet of transparent material placed over a camera lens or light source to modify the quality or color of the light passing through. (2) A feature in an image-editing application that alters or transforms selected pixels for some kind of visual effect.

flag Something used to partially block a light source to control the amount of light that falls on the subject.

flash meter A light meter especially designed to verify exposure in flash photography. It does this by recording values from the moment of a test flash, rather than simply measuring the "live" light level.

focal length The distance between the optical center of a lens and its point of focus when the lens is focused on infinity.

focal range The range over which a camera or lens is able to focus on a subject (for example, 0.5m to Infinity).

focus The optical state where the light rays converge on the film or CCD to produce the sharpest possible image.

fringe In image-editing, an unwanted border effect to a selection, where the pixels combine some of the colors inside the selection and some from the background.

frontal light Light that hits the subject from behind the camera, creating bright, high-contrast images, but with flat shadows and less relief.

f-stop The calibration of the aperture size of a photographic lens.

gamma A measure of the contrast of an image, expressed as the steepness of the characteristic curve of an image.

gradation The smooth blending of one tone or color into another, or from transparent to colored in a tint. A graduated lens filter, for instance, might be dark on one side, fading to clear on the other.

grayscale An image made up of a sequential series of 256 gray tones, covering the entire gamut between black and white.

halogen bulb Common in modern spotlighting, halogen lights use a tungsten filament surrounded by halogen gas, allowing it to burn hotter, longer and brighter.

haze The scattering of light by particles in the atmosphere, usually caused by fine dust, high humidity, or pollution. Haze makes a scene paler with distance, and softens the hard edges of sunlight.

HDRI (High Dynamic Range Imaging) A method of combining digital images taken at different exposures to draw detail from areas which would traditionally have been over or under exposed. This effect is typically achieved using a Photoshop plugin, and HDRI images can contain significantly more information than can be rendered on screen or even perceived by the human eye.

histogram A map of the distribution of tones in an image, arranged as a graph. The horizontal axis goes from the darkest tones to the lightest, while the vertical axis shows the number of pixels in that range.

HSB (Hue, Saturation, Brightness) The three dimensions of color, and the standard color model used to adjust color in many image-editing applications.

hue The pure color defined by position on the color spectrum; what is generally meant by "color" in lay terms.

incandescent lighting This strictly means light created by burning, referring to traditional filament bulbs. They are also know as hotlights, since they remain on and become very hot.

incident meter A light meter as opposed to the metering systems built into many cameras. These are used by hand to measure the light falling at a particular place, rather than (as the camera does) the light reflected from a subject.

ISO An international standard rating for film speed, with the film getting faster as the rating increases. ISO 400 film is twice as fast as ISO 200, and will produce a correct exposure with less light and/or a shorter exposure. However, higher-speed film tends to produce more grain in the exposure, too.

Joule Measure of power, see watt-seconds.

JPEG (Joint Photographic Experts Group) Pronounced "jay-peg," a system for compressing images, developed as an industry standard by the International Standards Organization. Compression ratios are typically between 10:1 and 20:1, although lossy (but not necessarily noticeable to the eye).

kelvin Scientific measure of temperature based on absolute zero (simply take 273.15 from any temperature in Celsius to convert to kelvin). In photography measurements in kelvin refer to color temperature. Unlike other measures of temperature, the degrees symbol in not used.

lasso In image-editing, a tool used to draw an outline around an area of an image for the purposes of selection.

layer In image-editing, one level of an image file, separate from the rest, allowing different elements to be edited separately.

LCD (Liquid Crystal Display) Flat screen display used in digital cameras and some monitors. A liquid-crystal solution held between two clear polarizing sheets is subject to an electrical current, which alters the alignment of the crystals so that they either pass or block the light.

light tent A tent-like structure, varying in size and material, used to diffuse light over a wider area for close up shots.

lumens A measure of the light emitted by a lightsource, derived from candela.

luminaires A complete light unit, comprising an internal focussing mechanism and a fresnel lens. An example would be a focusing spot light. The name luminaires derives from the French, but is used by professional photographers across the world.

luminosity The brightness of a color, independent of the hue or saturation.

LZW (Lempel-Ziv-Welch) A standard option when saving TIFF files which reduces file sizes, especially in images with large areas of similar color. This option does not lose any data from the image, but cannot however be opened by some image editing programs.

macro A mode offered by some lenses and cameras that enables the lens or camera to focus in extreme close-up.

mask In image-editing, a grayscale template that hides part of an image. One of the most important tools in editing an image, it is used to limit changes to a particular area or protect part of an image from alteration.

megapixel A rating of resolution for a digital camera, directly related to the number of pixels forming or output by the CMOS or CCD sensor. The higher the megapixel rating, the higher the resolution of images created by the camera.

midtone The parts of an image that are approximately average in tone, falling midway between the highlights and shadows.

modelling light A small light built into studio flash units which remains on continuously. It can be used to position the flash, approximating the light that will be cast by the flash.

monobloc An all-in-one flash unit with the controls and power supply built-in. Monoblocs can be synchronized together to create more elaborate lighting setups.

noise Random pattern of small spots on a digital image that are generally unwanted, which are caused by nonimage-forming electrical signals.

open flash The technique of leaving the shutter open and triggering the flash one or more times, perhaps from different positions in the scene.

peripheral An additional hardware device connected to and operated by the computer, such as a drive or printer.

pixel (PICture ELement) The smallest units of a digital image, pixels are the square screen dots that make up a bitmapped picture. Each pixel carries a specific tone and color.

plug-in In image-editing, software produced by a third party and intended to supplement a program's features or performance.

power pack The separate unit in flash lighting systems (other than monoblocks) which provides power to the lights.

ppi Or pixels-per-inch:- a measure of resolution for a bitmapped image.

processor A silicon chip containing millions of micro-switches, designed for performing specific functions in a computer or digital camera.

QuickTime VR An Apple-developed technology that allows a series of photos to be joined in a single file, which the user can then use to look around, say, a product or a room.

RAID (Redundant Array of Independent Disks) A stack of hard disks that function as one, but with greater capacity.

RAM (Random Access Memory) The working memory of a computer, to which the central processing unit (cpu) has direct, immediate access.

Raw files A digital image format, known sometimes as the "digital negative," which preserves higher levels of color depth than traditional 8 bits per channel images. The image can then be adjusted in software—potentially by three f stops—without loss of quality. The file also stores camera data including meter readings, aperture settings and more. In fact each camera model creates its own kind of Raw file, though leading models are supported by software like Adobe Photoshop.

reflector An object or material used to bounce available light or studio lighting onto the subject, often softening and dispersing the light for a more attractive end result.

resampling Changing the resolution of an image either by removing pixels (lowering resolution) or adding them by interpolation (increasing resolution).

resolution The level of detail in a digital image, measured in pixels (e.g. 1,024 by 768 pixels), or dots-per-inch (in a half-tone image, e.g. 1200 dpi).

RGB (Red, Green, Blue) The primary colors of the additive model, used in monitors and image-editing programs.

rim-lighting Light from the side and behind a subject which falls on the edge (hence rim) of the subject.

ring-flash A lighting device with a hole in the center so that the lens can be placed through it, resulting in shadow-free images.

saturation The purity of a color, going from the lightest tint to the deepest, most saturated tone.

selection In image-editing, a part of an on-screen image that is chosen and defined by a border in preparation for manipulation or movement.

shutter The device inside a conventional camera that controls the length of time during which the film is exposed to light. Many digital cameras don't have a shutter, but the term is still used as shorthand to describe the electronic mechanism that controls the length of exposure for the CCD.

shutter speed The time the shutter (or electronic switch) leaves the CCD or film open to light during an exposure.

SLR (Single Lens Reflex) A camera that transmits the same image via a mirror to the film and viewfinder, ensuring that you get exactly what you see in terms of focus and composition.

slow sync The technique of firing the flash in conjunction with a slow shutter speed (as in rear-curtain sync).

soft-box A studio lighting accessory consisting of a flexible box that attaches to a light source at one end and has an adjustable diffusion screen at the other, softening the light and any shadows cast by the subject.

spot meter A specialized light meter, or function of the camera light meter, that takes an exposure reading for a precise area of a scene.

sync cord The electronic cable used to connect a camera and flash.

telephoto A photographic lens with a long focal length that enables distant objects to be enlarged. The drawbacks include a limited depth of field and angle of view.

TIFF (Tagged Image File Format) A file format for bitmapped images. It supports cmyk, rgb and grayscale files with alpha channels, and lab indexed color, and it can use LZW lossless compression. It is now the most widely used standard for good-resolution digital photographic images.

top lighting Lighting from above, useful in product photography since it removes reflections.

TTL (Through The Lens) Describes metering systems that use the light passing through the lens to evaluate exposure details.

tungsten A metallic element, used as the filament for lightbulbs, hence tungsten lighting.

umbrella In photographic lighting umbrellas with reflective surfaces are used in conjunction with a light, in order to diffuse the beam.

white balance A digital camera control used to balance exposure and color settings for artificial lighting types.

zoom A camera lens with an adjustable focal length, giving, in effect, a range of lenses in one. Drawbacks include a smaller maximum aperture and increased distortion over a prime lens (one with a fixed focal length).

Index

Bibliography and useful addresses

Digital imaging and photography

Pro Photographer's D-SLR Handbook
Michael Freeman, *Lark Books*

The Complete Guide to Digital Photography, 4th ed.
Michael Freeman, *Lark Books*

The Complete Guide to Night & Low-Light Digital Photography
Michael Freeman, *Lark Books*

The Complete Guide to Light & Lighting
Michael Freeman, *Lark Books*

Digital Photography Expert Series:
Close Up
Light and Lighting
Nature and Landscape
Portrait
All by Michael Freeman, *Lark Books*

Creative Photoshop Lighting Techniques
Barry Huggins, *Lark Books*

Mastering Black and White Digital Photography
Michael Freeman, *Lark Books*

Mastering Color Digital Photography
Michael Freeman, *Lark Books*

Mastering Digital Flash Photography
Chris George, *Lark Books*

Web sites

Note that Website addresses may often change, and sites appear and disappear with alarming regularity. Use a search engine to help find new arrivals or check addresses.

Photoshop sites (tutorials, information, galleries)

Absolute Cross Tutorials (including plug-ins)
www.absolutecross.com/tutorials/photoshop.htm

Laurie McCanna's Photoshop Tips
www.mccannas.com/pshop/photosh0.htm

Planet Photoshop (portal for all things Photoshop)
www.planetphotoshop.com

Ultimate Photoshop
www.ultimate-photoshop.com

Digital imaging and photography sites

Creativepro.com (e-magazine) www.creativepro.com

Digital Photography www.digital-photography.org

123DI www.123di.com

ShortCourses (digital photography: theory and practice)
www.shortcourses.com

Software

Photoshop, Photoshop Elements, Photodeluxe
www.adobe.com

Paintshop Pro, Photo-Paint, CorelDRAW! www.corel.com

PhotoImpact, PhotoExpress www.ulead.com

Toast Titanium www.roxio.com

Useful addresses

Adobe (Photoshop, Illustrator) www.adobe.com

Alien Skin (Photoshop Plug-ins) www.alienskin.com

Apple Computer www.apple.com

Digital camera review www.dpreview.com

Epson www.epson.com

Formac www.formac.com

Fujifilm www.fujifilm.com

Hasselblad www.hasselblad.se

Hewlett-Packard www.hp.com

Kodak www.kodak.com

LaCie www.lacie.com

Microsoft www.microsoft.com

Nikon www.nikon.com

Nixvue www.nixvue.com

Olympus www.olympusamerica.com www.olympus.co.uk

Pantone www.pantone.com

Photographic information site www.ephotozine.com

Ricoh www.ricoh-europe.com

Samsung www.samsung.com

Sanyo www.sanyo.co.jp

Sony www.sony.com

Sun Microsystems www.sun.com

Symantec www.symantec.com

Umax www.umax.com

Wacom (graphics tablets) www.wacom.com